STILL LIFE

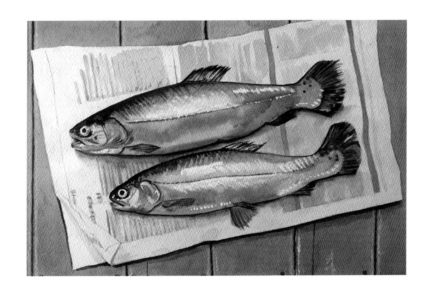

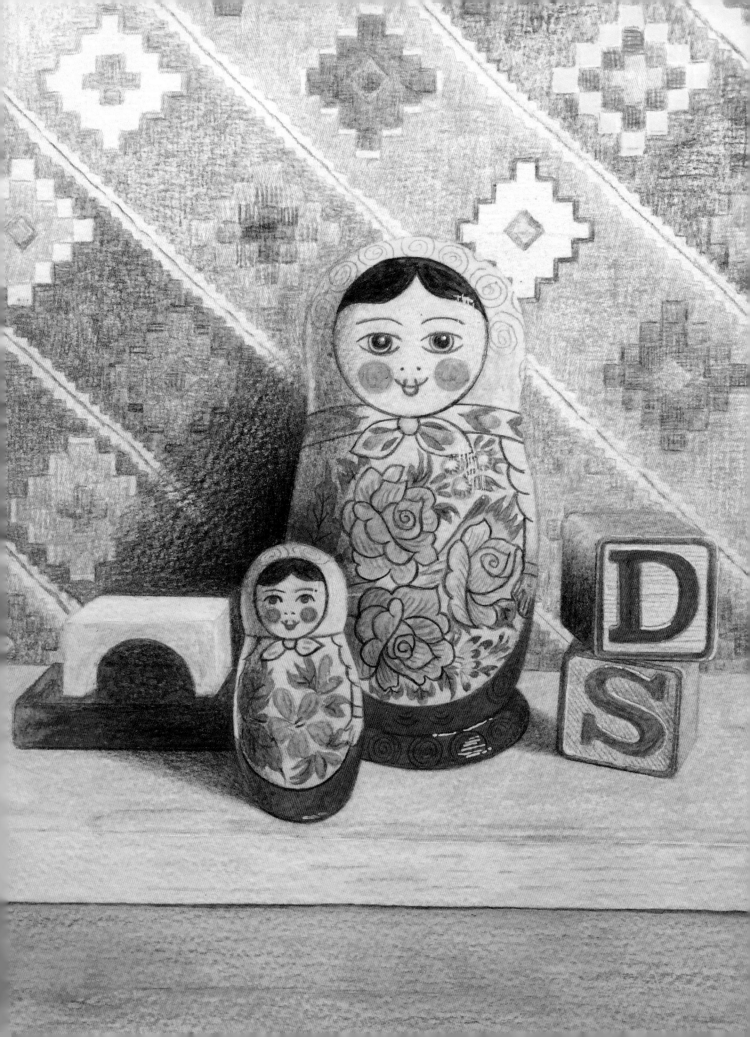

STILL LIFE

TECHNIQUES AND TUTORIALS
FOR THE COMPLETE BEGINNER

SUSIE JOHNS

First published 2021 by

Guild of Master Craftsman Publications Ltd

Castle Place, 166 High Street, Lewes,

East Sussex, BN7 1XU, UK

ISBN 978 1 78494 617 3

PUBLISHER **Jonathan Bailey**

PRODUCTION **Jim Bulley**

SENIOR PROJECT EDITOR **Dominique Page**

DESIGNER **Ginny Zeal**

PHOTOGRAPHY **Susie Johns**

Set in Baskerville Roman

Colour origination by GMC Reprographics

Printed and bound in China

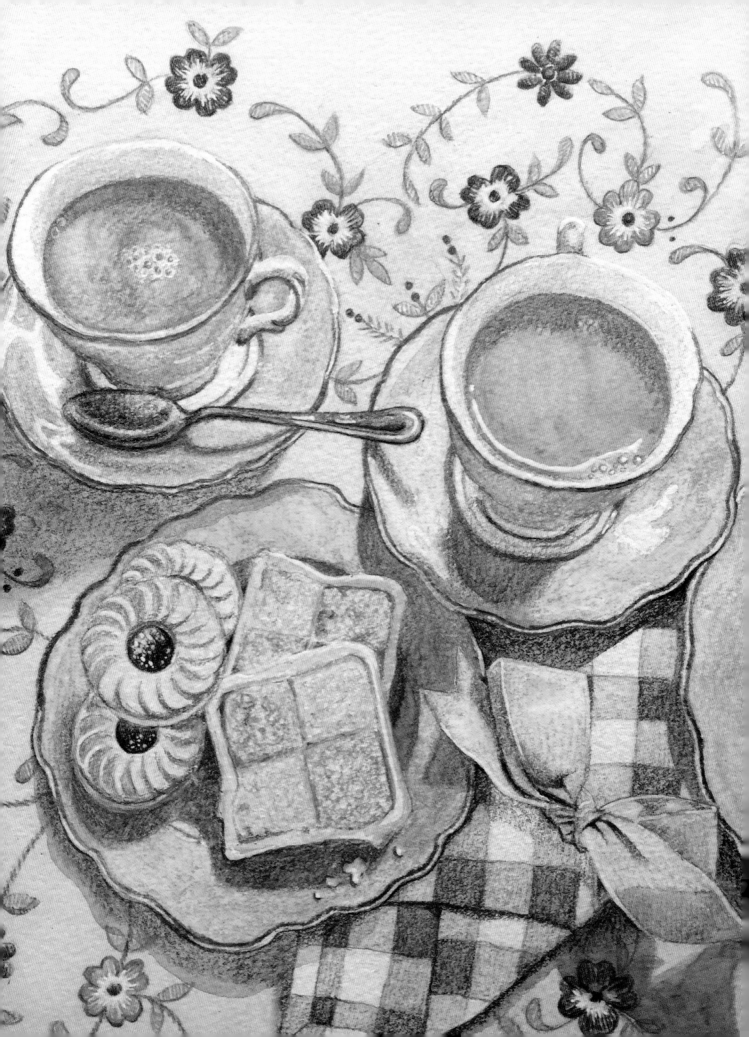

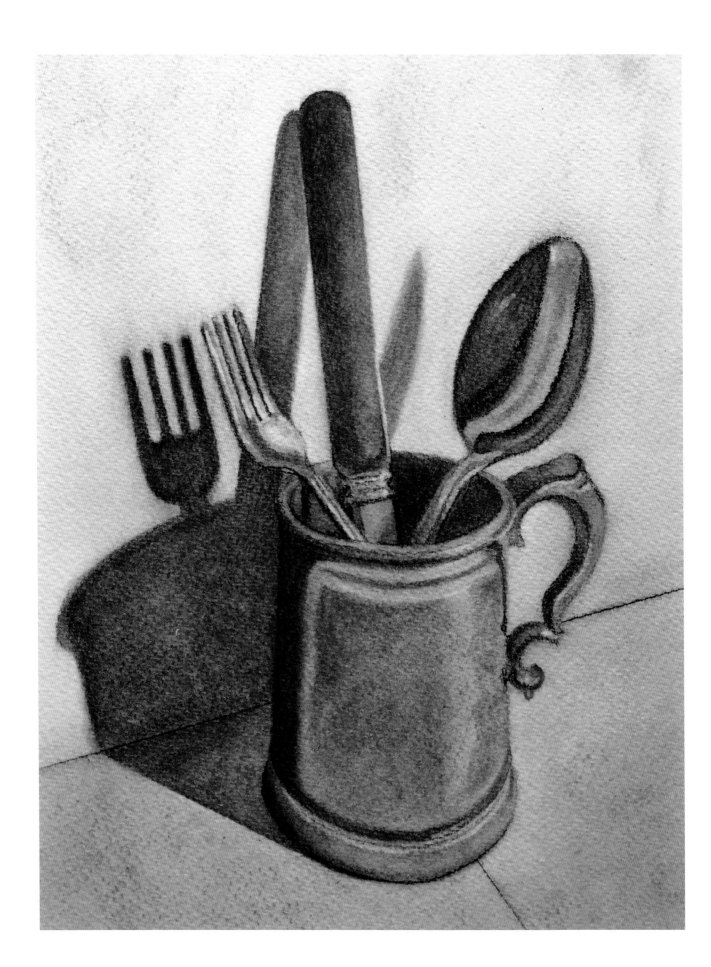

Contents

Introduction

As far as I'm concerned, there are two categories of still life: found and chosen. In the first category are things you just happen upon, that catch your eye: a set of keys; a cup of tea and some biscuits on the kitchen table; a tray of glasses; a vase of tulips; an open book or some art materials on a desk; toys on a shelf; or a watering can and some gardening tools abandoned by the back gate. You might take out your sketchbook and do a quick drawing, to capture these little discoveries.

The projects in this book belong to the second category, as they have been chosen and specially arranged – though their inclusion might have been inspired by one of these chance encounters.

For centuries, still-life objects appeared within portrait paintings or landscape paintings, but it was not until the mid-16th century that the still life started to become valued as a subject in its own right – and it enjoyed a golden age in The Netherlands throughout the 17th century. The objects depicted in these early still-life paintings tended to have allegorical meanings: jewellery and gold suggested wealth and power; books, maps and musical instruments symbolized learning; items such as wine or playing cards depicted earthly pleasures; while a skull, clock or burning candle denoted mortality. But there were also paintings of tables laden with foods from around the globe and abundant arrangements of beautiful flowers. From the 18th century until post-World War II, France became the centre of still-life painting. Cézanne was, arguably, the master of the still life. He studied the relationships between objects in nature and identified the sphere, cube, cylinder and cone as the four basic forms from which all things are comprised. You can see this when you look at his simple still-life arrangements of fruit. Then, there was a kind of still-life revival in the 1960s in America, when Jasper Johns made iconic sculptures and drawings of mundane items, such as beer cans and a light bulb; Andy Warhol made screen prints of Campbell's soup cans; and Roy Lichtenstein painted familiar still-life set-ups, such as a fruit bowl or flower vase, in his signature comic-book style, thereby transforming everyday objects into pop-art icons.

When I was an art student, I loved to draw objects such as food packaging and books with colourful covers – and more recently, in my drawing and painting courses, still life is one of the main themes. I try to teach my students useful techniques, such as

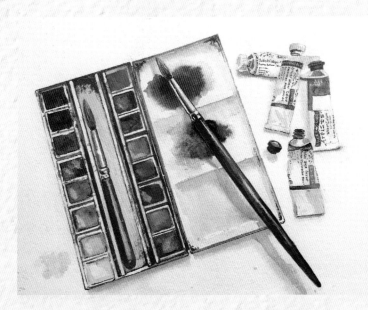

mark-making, perspective, negative space, proportion, scale, tone and line, as well as experimenting with different materials – but it's not just about techniques. I try to encourage them to make drawing a habit, something to do regularly, on a daily basis if possible. 'Carry a sketchbook with you,' I tell them, 'and make drawings at every opportunity.' But one of the things my students say to me often is, 'I don't know what to draw.' Honestly… subject matter is all around you. All the projects in this book involve drawing everyday objects that you should be able to find without leaving your house.

One more thing before we make a start: don't approach drawing believing that there is a right way and a wrong way of doing things. Discovering materials that you like to use and learning various mark-making techniques are just part of the process; another important part is learning to observe, so that you can draw things accurately. But the only way to improve your skills and develop a style of your own is by practising. You will make mistakes and you will learn from your mistakes, and sometimes you will make a drawing or painting that you will be really proud of – that is where the real learning begins.

Susie

Materials and Equipment

These pages contain a guide to the materials and equipment used in this book for the various projects and techniques. Because there is a range of media used in the book, there is quite an array of materials, which you may find a bit overwhelming. Start with just a few items and build up your art kit gradually, as you learn new techniques and try various mediums.

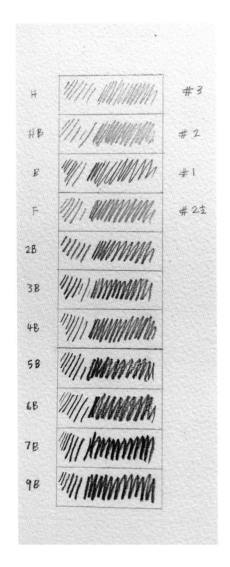

You can see from this chart how pencils, ranging from hard to soft (top to bottom), produce different types of line and tone. The universal grading scale is given on the left and the US equivalents for some of these on the right.

Graphite

The humble pencil, made from wood encasing a thin core of graphite, is a remarkably versatile drawing tool. The core, usually referred to as the 'lead', is made from graphite mixed with clay – and the greater the proportion of graphite, the softer and blacker the lead.

Available in grades from 9H to 9B, with the 'H' grades being hard and the 'B' grades being soft, the number indicates the degree of hardness or softness. So, a 5H pencil is harder than a 2H, and an 8B is softer than a 2B. An 'F' pencil is more or less equivalent to an HB or B but sharpens to a finer point. Start with just a few – HB, B, 2B, 4B and 6B – that will allow you to make a wide range of marks. You can always add more later.

Chunkier pencils are available, too, with thicker leads. When your pencil wears down to a short stump – and bear in mind that the softer the lead, the more quickly it wears down – a pencil extender will extend its life and restore it to a more useable length.

MECHANICAL PENCILS

These are available in some of the grades already mentioned and in a wide range of thicknesses, starting at 0.2mm diameter, which is too thin for most purposes, going up to 5.6mm.

Mechanical pencils are useful because, if the point breaks in use,

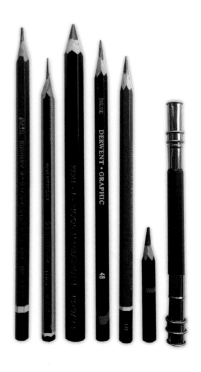

Graphite pencils, from left to right: HB, B, chunky 2B, 4B and 6B pencils; pencil stump; and pencil extender.

you can quickly push the lead up and carry on drawing without pausing to sharpen it – though there are special sharpeners available. You will need a stock of replacement leads in the right thicknesses.

GRAPHITE STICKS

For thicker, more gestural marks, you may prefer to use graphite sticks. These come in round sticks – long and thin or shorter and thicker – and in squarish sticks, and in various grades. They are useful for making a range of marks, using the tips, the edges or the sides of the sticks.

Charcoal

Natural charcoal is the cheapest and most available type, usually made from sticks of willow or grapevine, stripped of their bark and heated to a high temperature without oxygen. Natural charcoal contains no binding agents. It is soft, erases easily, and is brittle and therefore susceptible to breakage if not handled gently.

Compressed charcoal is made from charred wood pounded into dust, which is then bound with gum or wax and formed into sticks and into the cores of charcoal pencils. Various ranges of hardness and softness are available, producing dark or light marks, depending on the ratio of powder to binder. Compressed charcoal is harder than natural charcoal and can be sharpened to a point for creating fine detail. Marks can be difficult to erase, however, especially when laid on top of natural charcoal.

Nitram is a brand of charcoal available in different grades that offers some of the advantages of compressed charcoal – it can be sharpened, it's less prone to breaking, and it produces rich black marks – combined with some of the characteristics of natural charcoal, in that it can easily be blended and erased.

Coloured pencils

There are a number of brands of coloured pencil available and, within many of these brands, different qualities: student, studio and professional. All types are composed of colour pigments bound with wax and other ingredients, but they vary enormously in quality, and it is important to try as many different types as you can to find one that suits your style and purpose.

As a general recommendation, I would say you should choose professional-grade pencils, even if you are a beginner. Yes, they are expensive, but you don't have to invest in a whole set: they can be bought individually, so you can start with a small selection and add to them gradually.

Graphite sticks, from left to right: square profile, rectangular profile, chunky hexagonal and long round stick.

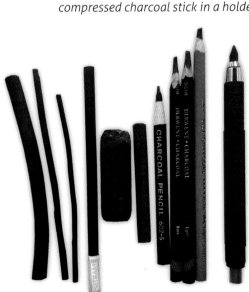

Charcoal, from left to right: natural charcoal in three different thicknesses; Nitram charcoal; compressed charcoal in two thicknesses; charcoal pencils in a range of grades; and a compressed charcoal stick in a holder.

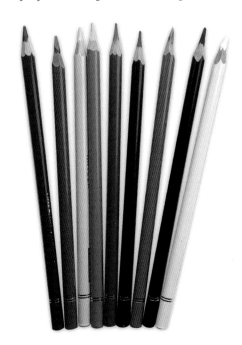

Start with a basic set of coloured pencils, including white, which is useful for blending and burnishing.

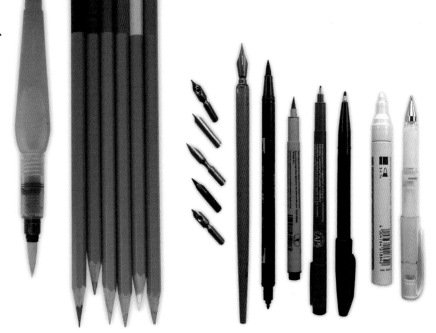

FAR LEFT *Watercolour pencils and a brush with water reservoir.*

LEFT *Pen and ink, from left to right: dip pen nibs and holders; dual-tip brush pen (water-soluble); brush pen (permanent); pigment liner; fibre-tip pen (water-soluble); white paint pen; and white gel pen.*

Watercolour pencils

These have similar qualities to coloured pencils, in that they can be used for drawing lines, cross-hatching, shading and colouring in – but when water is added, they dissolve into paint and can be coaxed with a damp brush into smooth blocks of colour, subtle gradations and delicate washes. A travel brush with a reservoir for filling with water is a useful companion to water-soluble media.

Erasers

An eraser is much more than a tool for rubbing out mistakes – it is a drawing tool in its own right, as you will soon discover. Ideally, your kit will include a plastic eraser, a putty eraser and some that are thinner in shape, for precise erasing, such as the pen erasers shown here. A battery eraser is very effective at rubbing out coloured pencil marks – even heavily burnished layers – but takes a bit of getting used to.

An eraser shield will help you to erase fine, precise shapes and create clean edges to your drawings. Purpose-made shields are available, but you can also improvise with a plastic stencil or, for small circles, a knitting needle gauge.

Pen and ink

Liquid ink, used with a dip pen and nib, is the traditional choice for pen and ink drawing. Modern alternatives include all kinds of felt-tip pens, markers, paint pens, gel pens, ballpoint pens and brush pens. Fountain pens, usually categorized as a writing tool, are also excellent for drawing. Marks made with permanent ink cannot be

Erasers, from left to right: block erasers, plastic (top) and putty (bottom); battery eraser with replacement sticks; pen erasers in three shapes and sizes; eraser shield (top); and knitting needle gauge (bottom).

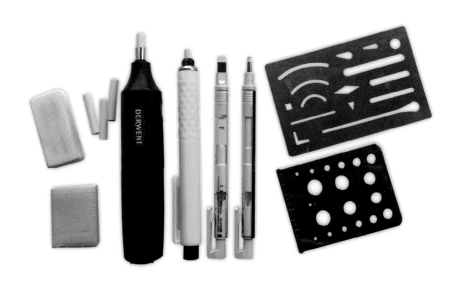

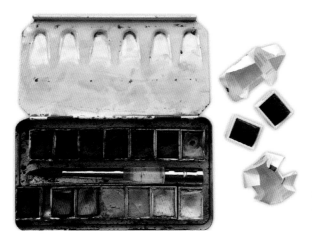

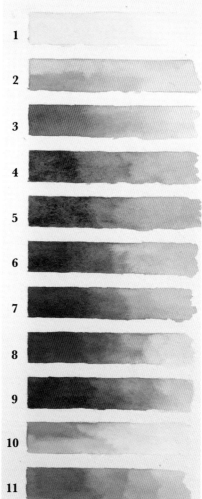

You can buy a set of half-pan paints, ready filled, or you can buy an empty palette and buy the half pans (or whole pans) separately, allowing you to choose your own colours.

erased, so it is important to be decisive when using this medium. Indian ink, when it has dried on the paper, is permanent and insoluble. Fountain pen ink, however, can still be dissolved and manipulated, even after the marks have dried. Similarly, some felt pens and markers produce permanent marks, while some are water-soluble (see page 69).

Watercolours

Watercolour paints, diluted with water, produce transparent colour. Colours are reduced in strength, the more water that is added, and pencil marks will show through the paint. Good-quality paints are made from ground-up pigments mixed with a binder – usually gum arabic – and are labelled 'artists' quality'. Cheaper ranges, including 'student' quality paints, tend to be made with less pigment and more binder, resulting in more opaque, less vibrant colours that often make less successful mixes. I would recommend that you buy artists' paints rather than student grade, as the superior quality will yield better results and help you gain confidence. You can buy watercolours in tubes or pans and you don't need many when you

Watercolour shades created from a limited palette of four colours:

1 *lemon yellow*
2 *lemon yellow + permanent rose*
3 *permanent rose*
4 *burnt sienna*
5 *burnt sienna + ultramarine*
6 *burnt sienna + ultramarine*
7 *ultramarine + burnt sienna*
8 *ultramarine*
9 *ultramarine + permanent rose*
10 *lemon yellow + ultramarine*
11 *lemon yellow + ultramarine + permanent rose*

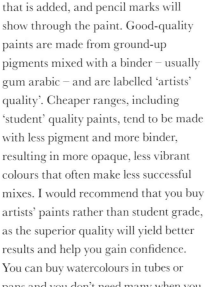

Watercolour is available in tubes of different sizes, depending on the manufacturer. A white china palette with separate wells is perfect for mixing paint.

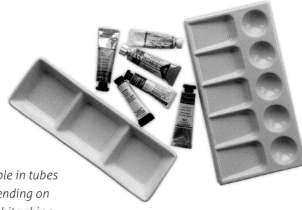

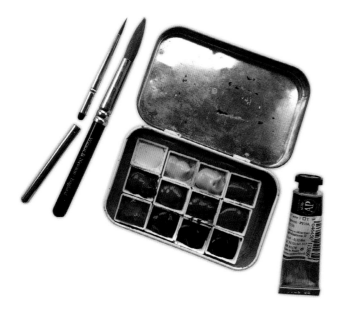

Make your own compact palette from a tin. Glue a magnet to the base of each pan, and add a small travel brush.

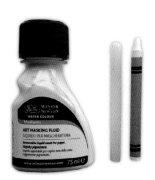

Masking fluid is available in small bottles or in pens (not shown). Wax can be used as a resist for water-based media: try using either a small candle or a white wax crayon.

are starting out, so it is a good idea to begin with a limited number of colours and add more as your confidence grows. The Fresh Fish tutorial on page 74 uses a limited palette of just four colours: lemon yellow, permanent rose, burnt sienna and ultramarine. These colours are all readily available from different manufacturers and can be mixed in various proportions to create a wide range of shades, including greys and neutrals (see page 13). They are useful for all kinds of subjects and are a good set to begin with.

Sets of good-quality watercolours are expensive – though they can sometimes work out cheaper than buying the colours individually. The downside to buying a set is that they usually contain colours that you wouldn't have chosen yourself; typically, a set will include cool and warm primaries plus one or more earth colours and sometimes black and white.

If you decide on tube colour, you will need a palette for mixing paint. A china palette is a good choice, as the surface allows a good flow of paint and

water, the white surface shows up the colours clearly, and it is easily washable. Many painters prefer a palette with a lid, however, which means you don't have to wash precious paint down the drain at the end of a painting session: close the lid to help to protect the paints from dust and prevent them from drying out. One of the advantages of good-quality watercolour paint is that, even if it has been left for days, weeks or months, it can be revitalized with a quick spritz of water. A small spray bottle is good for this purpose.

You can make your own palette from a recycled tin, such as an empty peppermint tin with a hinged lid. Buy empty half-pan or whole-pan containers from an art supplier and glue a small magnet to the base of each one, so it stays in place in the tin, then fill them up with paint.

If you decide you prefer pan colour, many manufacturers offer half pans (about 1.5ml) and whole pans (3ml) in lidded palettes of various sizes. A good option is to buy one that you can fill with your own choice of colours.

Gouache

In addition to watercolour paints, you will need a tube of white gouache, which can be used as a finishing touch, adding highlights to paintings. Gouache is very similar to watercolour, and can be used in the same way, but it's more opaque.

Masking

In some of the projects in this book, such as Tea and Cake (see page 62) and Fresh Fish (see page 74), white highlights have been added towards the end, using white gouache or ink. To preserve areas of white paper before you begin a painting, however, you can use masking fluid, a wax candle or a wax crayon.

Masking fluid, sometimes called drawing gum, or frisket, is a kind of liquid latex – though latex-free types are available – that is applied to the paper and allowed to dry. You can then paint over the area and, when the paint is dry, remove the rubbery mask to reveal the protected paper. Take care not to apply masking fluid to wet paper, as it will

sink into the fibres and, when you remove it, the paper will most certainly tear. Masking fluid acts as a temporary mask: when it's removed, you can still paint over the areas of paper that have been protected. Masking pens containing masking fluid are also available.

Alternatively, you can use a small wax candle or a white wax crayon: use one of these to draw the highlights and, when you add paint, the wax will act as a resist. This method is quicker, but the wax will remain on the paper, so you will not be able to add paint to those areas.

Brushes

In the projects that use watercolour and watercolour pencils, I have used round brushes in four sizes: 2, 4, 6 and 12. The bigger the number, the fatter the brush – but these sizes are only a guide, as numbering will vary from one manufacturer to another. I like to use sable brushes, which have the capacity to hold a lot of wet paint while maintaining a fine tip for detailed

Papers, from left to right: heavyweight cartridge; Bristol vellum; cold-pressed watercolour paper; hot-pressed 100% cotton watercolour paper; and cold-pressed 100% cotton watercolour paper.

brushwork – but they are expensive and there are lots of good synthetics or synthetic-sable mixes available to suit most budgets.

Paper

Only five types of paper have been used for the projects in this book. For general drawing purposes, particularly for pencil and charcoal, cartridge paper is a good choice. I would recommend a heavyweight cartridge

(135lb/220gsm), though a lighter cartridge (60lb/130gsm) can be used for practise. For coloured pencils, cartridge paper is also suitable, though you might choose to progress to Bristol vellum (100lb/270gsm), which is more expensive but has a surface that allows the build-up of lots of layers of colour.

For pen and ink, or line and wash, a hot-pressed watercolour paper has just the right kind of smooth surface that allows the pen to glide and produce unbroken lines, but is also sympathetic to the application of washes of watercolour. If you are using very light applications of paint, a 90lb (190gsm) paper or a slightly heavier 140lb (300gsm) is adequate, but for more watery washes, you might prefer to use a heavier paper, greater than 140lb in weight.

For watercolour paintings, I have suggested using a 140lb cold-pressed paper, which has more texture than the hot-pressed types. I would recommend using a 100% cotton paper such as Arches Aquarelle or Saunders Waterford or, if you are looking for a more affordable product, Bockingford, made from cellulose pulp, is a popular choice.

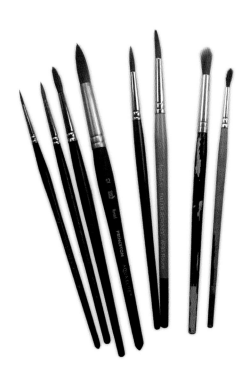

Watercolour brushes, from left to right: sables, sizes 2, 4 and 6; synthetic 'sable', size 12; two size 6 synthetics, showing slight variation in size; and two cheap brushes, displaying splayed hairs and flaking paint on handles.

Sketchbooks

It cannot be emphasized enough how useful a sketchbook can be in developing drawing skills. Take a sketchbook with you wherever you go and get into the habit of drawing every day, if you can.

A sketchbook can be a private place to express your thoughts, to practise techniques, to try things out, test new materials, make notes for future reference, jot down ideas, or plan a larger-scale drawing.

I find a 5½in (14cm) square hardback sketchbook with good-quality cartridge paper pages the most useful. It is robust and will fit into a pocket or small bag. You can work on a single square page or across two pages. Some people prefer a rectangular format and some people favour a spiral-bound pad. The choice is yours.

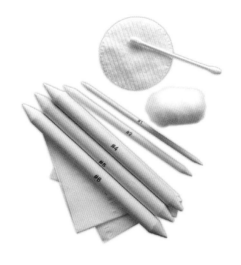

Materials that are useful for blending various dry media, such as graphite, charcoal and coloured pencils, from top to bottom: a cotton wool pad; cotton bud; cotton wool ball; paper stumps of various sizes; and paper tissues.

Sharpeners

Most drawing kits include a pencil sharpener, but you might want to consider using a sharp blade, such as a craft knife or scalpel, which can be useful for creating a longer point on most pencils. Sandpaper is also useful for creating a fine point on pencils, graphite sticks and charcoal, as well as all types of coloured pencils.

Tissues, paper stumps and cotton wool

Keep tissues on hand, not only to mop up spills, dry paintbrushes and wipe palettes but also – in preference to greasy fingertips – to smudge and blend marks made with pencil and charcoal. Paper stumps are also good for smudging and blending, and so are cotton wool balls, pads and buds (Q-tips).

Rulers and drawing compass

Rulers are, of course, good for measuring and drawing straight lines, while a compass is invaluable for drawing accurate circles.

Drawing board and easel

A drawing board is an essential piece of equipment. You can improvise with a sturdy piece of plywood or MDF.

An easel is a useful addition to your kit. You'll find it is mentioned in some of the projects.

Sharpeners, from left to right: sandpaper and sandpaper block; scalpel; penknife; and metal sharpeners for different-sized pencils.

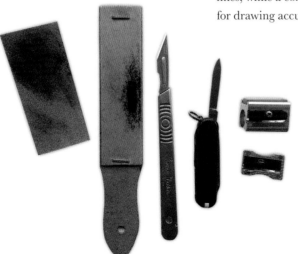

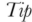

Tip

When using an easel the centre of the picture surface should be level with your shoulder. If you are right-handed, you should position your subject towards the left side of the easel and, if you are left-handed, towards the right.

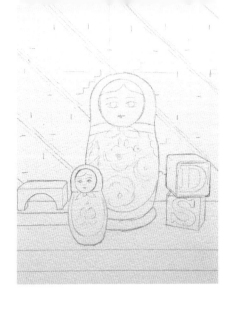

Line

The most basic drawings consist of lines: when we first pick up a pen or pencil and start making marks on paper, we begin with line. Lines can be thin, thick, consistent or varying in thickness; light or dark; short and long; pointing in different directions; straight, sinuous or jagged; describing outlines, shapes and contours; or packed close together to create areas of tone.

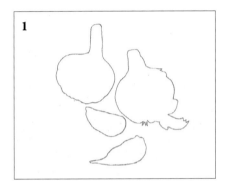

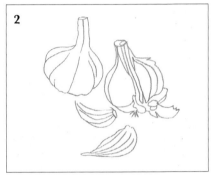

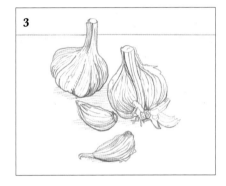

Contour lines

A lot of drawings and paintings begin with line. The word 'contour' is from French and means 'outline'. A simple outline (**1**) might describe the basic shape of an object, like this garlic, but a few contour lines (**2**) begin to define the structure, and a few more (**3**) help to describe its three-dimensionality without the use of shading.

Making marks

Different drawing materials create differing types of line and it is well worth experimenting with various media to discover for yourself what this means and how you can use a range of mark-making tools in your projects. Devote a few pages of your sketchbook to exploring the various tools and materials in your art kit and label them.

In this way, not only can you spend a few enjoyable hours discovering the versatility of your pencils, pens and so on, but you can also build up your own source book of lines and marks for future reference.

Exploratory lines

When making a drawing, it is a good idea to start with light pressure until you are sure the marks you are making are in the right place. Sometimes the lines will be long and smooth, particularly if you are confident about describing a certain shape; at other times the lines might be more tentative as you feel your way around a shape or tackle something that you perceive to be a bit more difficult or challenging.

Small, tentative exploratory marks help you to find the right path for your lines and, when you are convinced that they are correct, you can go over them more firmly and with more conviction, making them darker and more precise.

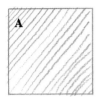

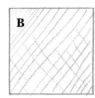

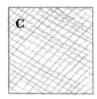

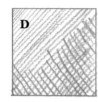

Creating tone with line

Hatching is a method of creating a variety of tones by laying down single strokes, close together or far apart, in parallel lines and, in the case of cross-hatching, lines crossing each other. Try it yourself: using a sharp pencil or a pen, make a group of parallel marks (**A**). This is called a 'set'. Practise changing the direction of the marks,

until you have found a direction that suits the way you draw. You may find that longer or shorter marks are easier for you, too. Now make another set of marks on top of the first (**B**). These are 'cross' marks and form a distinctive cross-hatched pattern. Hatched lines that are light or far apart, create light tones (**C**), while those that are darker and closer together form darker tones (**D**).

It's a good idea not to make areas of hatching too controlled, or the resulting drawing may appear too technical. If it helps, try holding your pencil or pen further up, away from the tip, to encourage looser, more spontaneous marks (see 'holding a pencil', below).

Holding a pencil

A pencil is a familiar object to most of us – and easy to use. By holding your pencil in different ways you can achieve

a wide variety of marks, and discover which positions feel the most comfortable for you.

The first is the way you'd hold it if you were writing (**1**). This gives you plenty of control but not much flexibility of movement. Also, it tends to allow you to use only the tip of the pencil, for creating fine, controlled marks.

By holding it a little further up, you increase the arc of movement, allowing you to make more sweeping strokes (**2**).

By turning your hand so that the end of the pencil nestles in your palm, you can move it in different directions and at different angles to the paper (**3**).

With an overhand grip, placing all four fingers on top and your thumb underneath, you can hold the pencil relatively flat to the paper, creating broad strokes with the side of the lead and easily varying the pressure as you draw, as well as allowing you to shade more easily (**4**).

With the same grip as in number 4, rotate your hand so that your fingertips are underneath; this allows you to make sweeping arcs for more gestural marks (**5**).

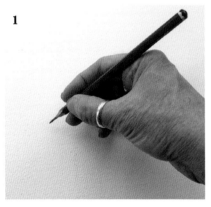

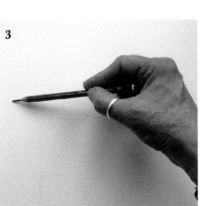

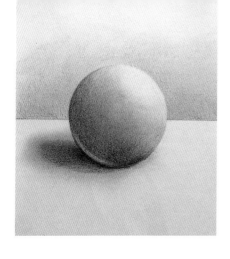

Tone

Learning to depict tone – creating shadows and highlights, and nuances of value – will help you to achieve depth and dimension in your drawings. A good range of tonal value in a picture creates the illusion of space and three-dimensionality.

Differences in tone – from light to dark – are called *values*. A complete value scale goes from pure white to pure black, with many gradations in between. When drawing with pencil or charcoal, the lightest possible areas are usually created by leaving the white of the paper untouched, and the darkest areas by applying the medium in a solid block so that no paper is visible.

Creating tone

On the previous pages we looked at using line. You can see from the drawing of the ivy leaf (above right) that a line drawing can describe the shape of

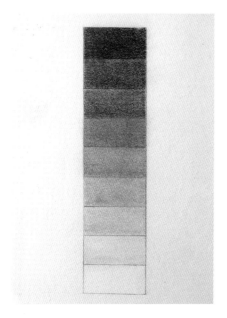

Here is a graded scale of nine tonal values, drawn with a 6B pencil.

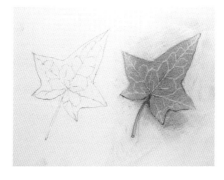

the leaf and the pattern of leaf veins, but the tonal drawing gives us a more accurate rendition, as it explains that the leaf is dark and the veins are light.

Describing form

When light strikes a three-dimensional object, it creates a light side, a shadow side and a cast shadow. The shadow side will not be evenly dark because reflected light bounces off other objects, into the shadow area.

As an exercise, place a round object such as a ball (top left) on a white piece of paper, light it from one side and make a drawing, using graphite or charcoal. Notice how the lightest tonal value is where the light strikes the object and the values darken as the surface of the object turns away from the light. The area that is furthest away from the light will have the darkest value. There will also be an area of light tone on the dark side, where the horizontal surface is reflected in the object.

Light and shade do not account for all the tones in a drawing. If you are making a monotone drawing of coloured objects, you will also have to consider the different tonal values of the various colours. See how the colours of the fruits below, when seen in a black and white photograph, become tonal – that is to say, shades of grey. The lemon is the lightest value, the orange a mid-tone and the tomatoes are the darkest in this example.

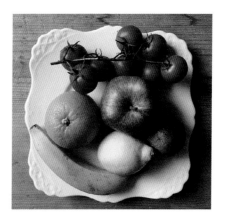

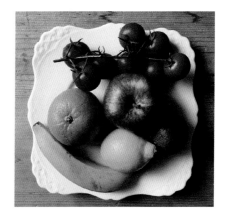

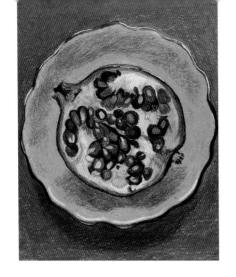

Colour

When you include colour in your drawings, it is important to understand how to mix colours, and why and how colours can affect one another. Mixing watercolours takes quite a bit of practice, so try making a colour wheel to help you understand why, for example, red and blue do not always make purple.

The colour wheel

This is one of the most useful devices for understanding colour. As an exercise, I suggest that you make your own colour wheel using your watercolour paints. There are two reasons for this. Firstly, by using your paints to create a colour wheel, you will understand how the three primary colours in your palette – red, yellow and blue – can be mixed to make a whole rainbow. Keep the finished colour wheel as a reference for future colour-mixing. And if you have more than one red, yellow or blue in your painting kit, make more colour wheels, using different primaries. Secondly, by producing a colour wheel, you can see how colours are related to one another.

To make a colour wheel, start by drawing a circle on your paper. Draw a smaller circle inside, and an even smaller circle inside that; then divide the two outer rings into 12 equal segments. Paint three of the segments using primaries: start with red, leave three spaces, paint the next segment yellow, leave three spaces, and paint the next segment blue.

Now, for the segment halfway between red and yellow, mix the two colours to make an orange that is neither too red nor too yellow, but halfway between the two. For the segment halfway between yellow and blue, mix the two colours to make green; and for the segment halfway between blue and red, mix the two colours to make violet. These three mixes are known as the secondary colours.

There are still six segments left to paint. These will contain the tertiary colours. To create a tertiary, mix a primary with the secondary that is next to it: so, mix red with orange to make red-orange, and red with violet to make red-violet, then paint the appropriate segments with these colours. Do the same with yellow, mixing it with orange to make yellow-orange and with green to make yellow-green. Now, mix blue with violet to make blue-violet and with green to make blue-green.

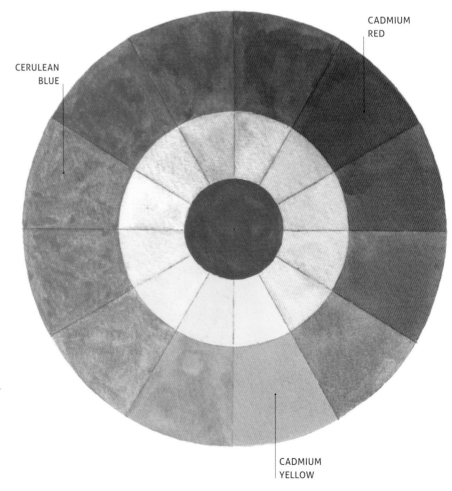

CERULEAN BLUE

CADMIUM RED

CADMIUM YELLOW

Each time you paint a segment, water down some of that colour to make a lighter colour, or 'tint', and use it to fill the inner segment. This will provide you with a useful reference, to see how each hue appears when it's made into a lighter wash. Finally, mix the three primaries in more or less equal proportions, to create a neutral dark shade and use this to fill in the small circle in the centre.

You probably already knew the basics of colour-mixing: red and yellow make orange; yellow and blue make green; and blue and red make purple. But this is not always the case. There are two examples of colour wheels shown here, to illustrate how the choice of primaries can affect the mixes, producing different secondary and tertiary colours. That's why it's important to paint your own colour wheels, so you can see what a difference it makes to select the right colours for what you are going to paint.

Colours are often described as being 'warm' or 'cool'. The warm colours include yellows, reds and oranges, while broadly speaking, the cool colours are blue, violet and green. But it's not quite that simple, as there are cool reds and warm blues, for example. A warm red will have a little yellow in it, while a cool red will have a little blue in it. An example of a cool red is permanent rose, while cadmium is a warm red. This is why, on the two colour wheels, while the oranges are reasonably similar, the greens look very different and so do the violets.

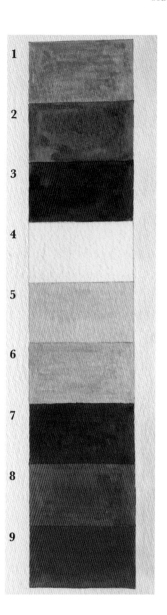

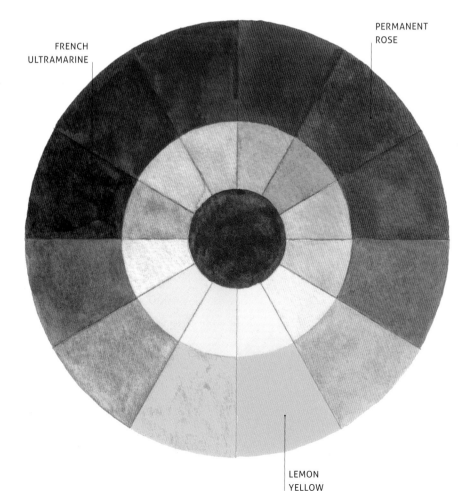

1 cerulean blue (cool) *2 cobalt blue (warm)* *3 French ultramarine (warm)* *4 lemon yellow (cool)* *5 cadmium yellow (warm)* *6 new Gamboge (warm)* *7 Alizarin crimson (cool)* *8 permanent rose (cool)* *9 cadmium red (warm)*

The colour wheel on the left is made using permanent rose, lemon yellow and French ultramarine; while the one on the far left is cadmium red, cadmium yellow and cerulean blue. See what a difference the two sets of primaries make when mixing secondary and tertiary colours.

FRENCH ULTRAMARINE

PERMANENT ROSE

LEMON YELLOW

Colour theory

You have no doubt heard the saying, 'opposites attract'. The colours that lie opposite one another on a colour wheel, known as complementary colours, have a powerful effect, helping to intensify each other. Make use of this effect by combining complementaries in your compositions: the pomegranate on a green plate (see page 20), for example, the oranges on a blue plate on page 24, or the yellow and violet cups and egg cup on the facing page. When used side by side, these colours will enhance each other, and when mixed together they will neutralize each other – so use the mixes to produce subtle, harmonious shadows. When you look at a colour, you are probably not aware of this, but your eyes actually see its complementary as a shadow right next to it.

There are other colour combinations that you might wish to exploit. Split complementaries use a colour and the two adjacent tertiary colours of its complement. So, for red, this would be blue-green and yellow-green; for yellow, it would be red-violet and blue-violet; for blue it would be red-orange and yellow-orange (as in the garden objects on page 80). Analogous colour schemes – often found in nature – use three adjacent hues on the colour wheel, such as red, red-orange and orange; or yellow with various greens. These combinations usually match well and create a harmonious effect. Monochromatic colour schemes, meanwhile, use different values – or tones – of the same colour.

Colour qualities

Every colour has three qualities: hue, tone and intensity. The word 'colour' is a general term used to describe every hue, tint, tone or shade we see, including white, black and grey.

HUE

This refers to the pure colour, or the colour family, and usually includes the three primaries and the three secondaries: red, blue, yellow, green, orange and violet. Other colours belong to these families: magenta is a red, for example, olive is a green, and so on.

When the word 'hue' appears on a paint label, however, it indicates that a substitute has been used to replace the original pigment. So, for example, cadmium red hue doesn't contain cadmium, and cobalt blue hue doesn't contain cobalt; in both cases, an alternative has been used, usually manufactured rather than sourced from nature, in order to create a similar colour. Hues are not necessarily inferior to the original pigments and can help to lower the price of the paints.

TONE

The tone of a colour is its darkness or lightness. As a colour darkens, the gradations of tone are called shades; as a colour lightens, the gradations are called tints.

INTENSITY

The purity of a colour – its brightness or brilliance – is referred to as its intensity. A highly intense colour is bright, while a low-intensity colour is muted. Colours are at their purest when they are not mixed with another colour; as soon as you mix colours, their intensity is diminished. Mixing two complementary colours – in effect, all three primaries – creates a neutral shade.

These three examples, all done with coloured pencils, show the three different pairs of complementaries.

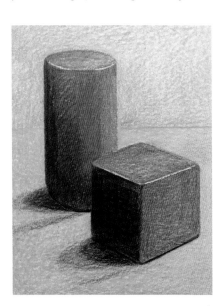 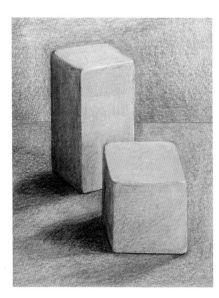 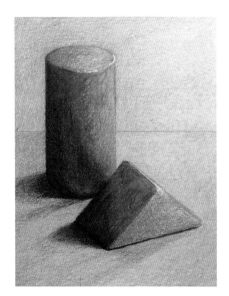

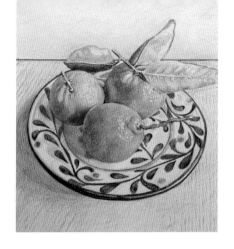

Composition

A composition consists of a number of shapes within a border. The idea is to arrange those shapes into a pleasing pattern to ensure that your finished still life – whether eye-catching and dynamic or calm and restful – is a success.

When presented with an arrangement of objects to draw, many new students just draw the objects, without thinking about what else to include in the picture. What else is there? Well, there is the surface that the objects are sitting on, the background, the shapes between the objects, the shadows and the reflections, for a start.

A weak composition – resulting in an unsuccessful finished picture – is nearly always the result of launching into a drawing before you have thought about where and how to position the various elements. By 'elements', it is important to bear in mind that it is not only the shapes of the physical objects in front of you that you need to think about: the shapes between the objects, the relationships between those objects and the overall balance of the arrangement all need to be taken into account. You will also need to consider tone and, if you are using coloured drawing or painting materials, you will need to think about colour.

And there is another important decision to be made: the angle from which you are viewing your subject matter or still-life arrangement.

Choosing and arranging

It is not just the shapes of the objects that make up a composition but also the shapes in between (see Focus on Negative Space, page 40). You can, of course, make an interesting picture of a single object (**1A**), but try adding other elements to see how much more effective this can be. When adding a second object, try not to make it identical, as a pair of items that are the same can compete with each other for attention, rather than complementing one another. Instead, consider changing it in some way – in this case, a second pear has been cut in half (**1B**). You can also introduce other items, to create balance – such as a plate to add a contrasting colour and shape, and a knife, to help create a theme or narrative (**1C**).

Tip
Take time to set up a still life before you start drawing or painting, thinking very carefully about the overall composition.

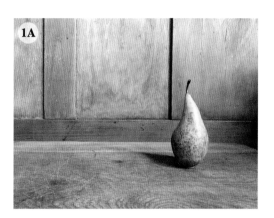

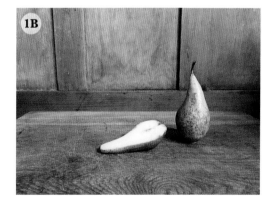

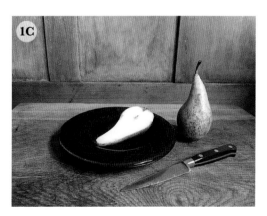

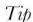

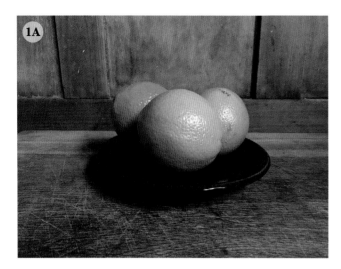

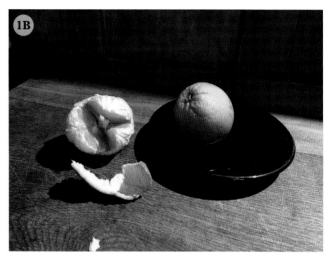

Focal point

You may have heard the advice that a successful composition comprises three objects. This is true – up to a point – but it is not enough to rely on this 'rule'. Here, three oranges arranged on a blue plate lack impact and interest (**1A**). This is partly because they are all the same shape and size, and partly because they are placed centrally and symmetrically, giving an overall impression that is formal and rather static. The second version (**1B**) involves the same blue plate but three 'elements' of the oranges. By including one whole orange, one peeled orange, and a piece of the peel, different shapes and colours and shadows have been introduced, and the viewpoint has also been altered, resulting in a more eye-catching, asymmetrical arrangement.

Cropping

Cropping brings the viewer in closer to the subject of the picture and breaks up the background. Revealing only parts of some of the objects, cropping can create a sense of design or abstraction, with more emphasis on shapes, tones and angles, and less emphasis on the items themselves.

When presented with a still-life arrangement in a classroom setting, students with limited experience of drawing will often try to draw everything in front of them – but a haphazard arrangement of items can be distracting and lacking in focus, so it pays to spend some time being selective and deciding where the boundaries of the drawing will be and whether an object is going to be in or out of the picture. Try using a viewfinder: a piece of card with a square or rectangle cut out of the centre. View the still-life set-up through the viewfinder, as you would through the viewfinder of a camera, moving it around to see

different viewpoints. This is also a good time to decide whether your format – the overall shape of your picture – should be square or rectangular, landscape or portrait. The square shape is rarely seen in classical works of art but is a very popular modern format, perhaps partly due to the popularity first of Polaroid photographs and, more recently, of Instagram.

Once you have begun arranging your objects, an effective way to plan your composition is to make thumbnail sketches, which will help you to see the shapes, proportions, relationships and balance of the arrangement, and to move things around if necessary.

A single arrangement can be depicted in various formats: landscape (horizontal), portrait (vertical) or square. Use a viewfinder to help you decide which works best.

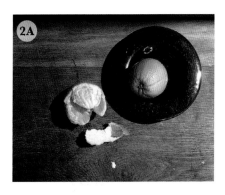

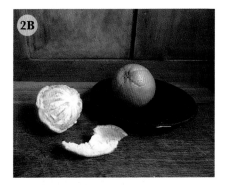

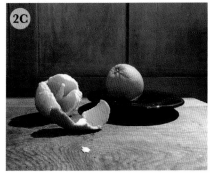

Viewpoint and perspective

The photographs on the left show how different an arrangement can appear when viewed from different angles or aspects.

Viewed from above (**2A**), you can see the top of the objects and the surface; the plate appears as a complete round shape. There is no 'horizon' line, and no background, as such, but an important part of the composition is the surface the items are sitting on – or the spaces between the items.

If you lower your viewing position (**2B**), you can see not only the top of the objects but also the sides, the surface they are sitting on and the vertical surface behind. The plate now appears as an ellipse.

When you look at the subject straight on (**2C**), more or less at eye level, you are viewing the aspects of the objects that are facing you. The plate is now a long, slender ellipse and the shadow shapes are much thinner too. The vertical surface becomes more prominent, with defined areas of negative space.

Make several thumbnails to compare different arrangements and to judge which set-up is the most successful.

Another important consideration is lighting: a well-lit arrangement will give depth and an illusion of three-dimensional space to your drawing or painting. A single source of light, preferably from one side, will create a clear pattern of shadows and highlights that helps to describe the various forms of the objects and create interesting negative shapes. Cast shadows help to link disparate items and create a sense of unity.

Of course, a still life happened upon by chance rather than by arrangement – found rather than chosen – will have its own particular charm. Instead of becoming too concerned with creating a composition from scratch, keep a lookout for still-life arrangements that may already exist among the clutter of everyday life – and make sure you have a sketchbook handy.

The Rule of Thirds is a compositional device where the picture format is divided equally into three, both horizontally and vertically, producing nine segments and, where the lines cross, four focal points. By placing key elements along the lines or at the junctions, the idea is that you can create a harmonious, balanced composition. This is just a guideline, of course, and instead of worrying about such measurements, you can rely on your instincts.

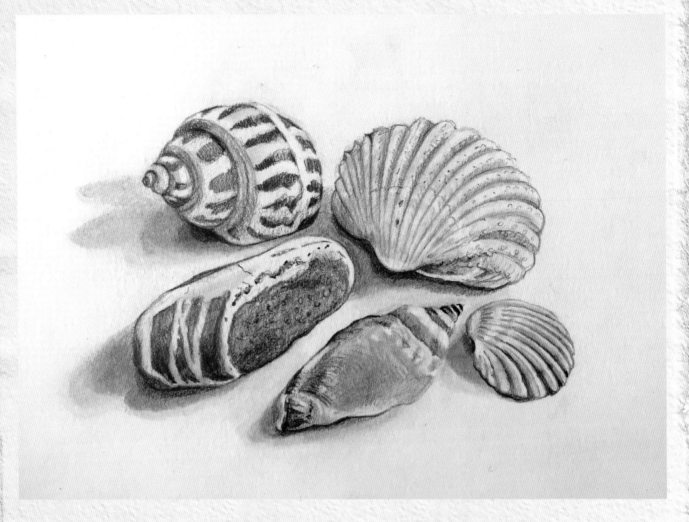

Pebble and Shells in Graphite

For this first tutorial, a few seashells and a pebble have been selected for their interesting and contrasting shapes. By drawing these, you will learn how to create a simple line drawing, then transform it by adding areas of tone. Graphite pencils are perfect for creating a range of tones, from light to dark.

YOU WILL NEED

graphite pencils: HB, 2B, 4B and 6B • blending stump
tissue • pen eraser • heavyweight cartridge paper

To create a tonal drawing of your arrangement of shells, you will start with a line drawing, then build up areas of tone. By doing this, on a flat, two-dimensional piece of paper, you will create the illusion of three dimensions: light and shade, form, space and texture. It's really quite remarkable what you can achieve with just a pencil or two.

Graphite is an ideal medium for the inexperienced artist because it can be smudged, blended and erased, so you can make changes and correct mistakes. You will be using hard and soft pencils: a hard pencil produces a finer, crisper line that is relatively light in tone, while a soft pencil is useful for making softer marks and producing a range of tones from light to dark.

The drawing will be done on white paper, using the white of the paper for the highlights. The paper should not be too smooth: paper with a little bit of texture will allow you to build up darker tones; however, as this is a relatively small-scale drawing, the paper should not be too textured either, or it will be difficult to create fine detail. A good-quality cartridge paper is ideal.

Setting up

For a tonal drawing, it helps if the subject includes plenty of light and shade. Arrange your items on a piece of white paper. Place the arrangement near a window, with the light coming from one side, creating shadows. If this is not practical, use an artificial light source, such as a lamp, placed to one side. Here, the light is coming from the right, forming shadows on the left-hand side of the objects. Because they are sitting on a white surface, the shadows are clean and easy to distinguish.

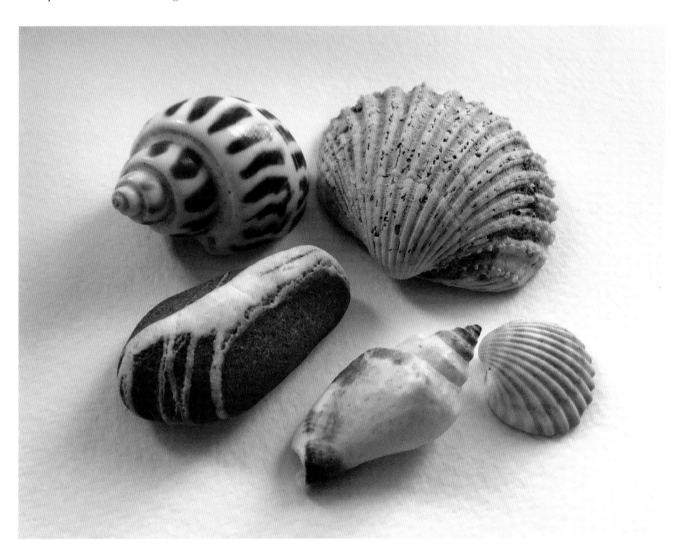

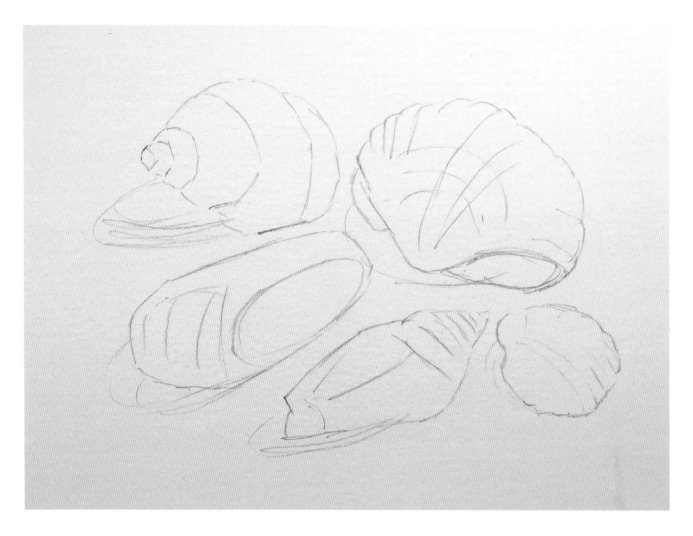

STAGE 1

Using an HB pencil, mark out the shapes of the shells and the pebble. Try to look at the overall shapes, but don't just draw the outlines. By breaking up each shell into several basic shapes you will be able to draw them more accurately. So, look at the overall shape of each one and also any internal shapes that you can discern. You can also include the general shapes of the cast shadows at this stage, as this will help you to get the spaces between the objects correct. Keep the marks as light as possible.

I have suggested using four different grades of pencil for this project. In the picture on the left they are, from top to bottom: 6B, 4B, 2B and HB. Use the HB for the initial marks, using very light pressure. If you find the marks are too light, then try the 2B for this stage instead. The 4B pencil or the 6B, or both, are better for the tonal areas in the later stages of the drawing.

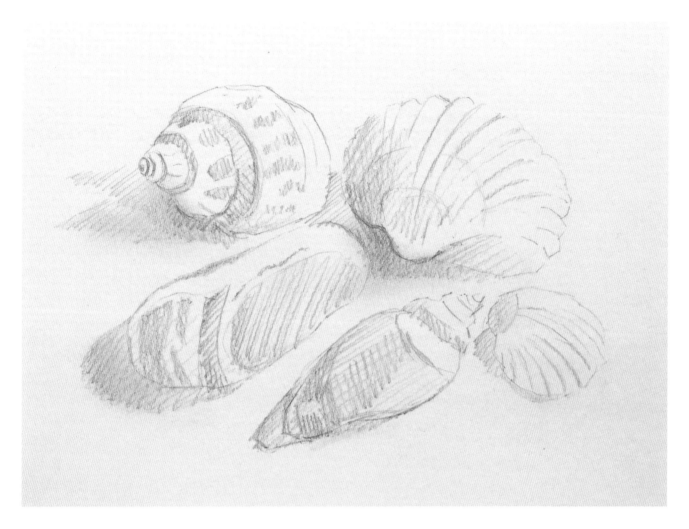

STAGE 2

When you are happy with the initial marks, use a softer pencil – 4B or 6B – to block in some of the broader areas of tone without worrying about the fine details at this stage. Use the tip of the pencil for smaller marks and the side of the lead for larger areas (see inset).

Hold the pencil so that it is quite flat against the paper (see page 18 for different ways of holding a pencil). This will help you to control the pressure as you block in areas of tone.

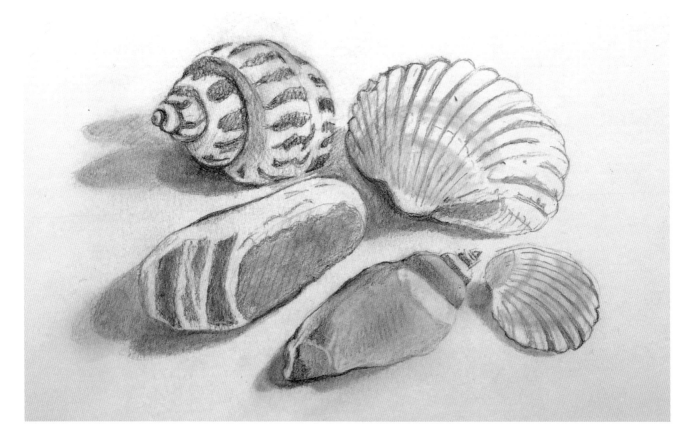

STAGE 3

For the shadows, look for variations in tone. Use the 4B pencil or the 6B, or both, to build up the tone, stroking the side of the lead across the surface of the paper to increase the tonal value gradually. At this stage you should aim to add the ranges of mid-tone to the drawing.

Blend some of the areas with tissue or a paper stump to soften it (see insets). The blending process pushes the graphite particles into the paper's surface and, at the same time, lifts some of the loose particles from the surface. In this way, you will produce a smoother effect, but it will be slightly lighter in tone; so, if you want a darker result, you may need to apply more graphite and repeat the process. Soften and blend some areas but not others. For example, you could soften the shadows to make them more velvety and smooth, but leave the areas of the shells or pebble where you want to preserve some texture.

To smudge and blend the tonal marks, do not use your bare fingers, as this tends to leave greasy marks on the paper. Instead, wrap some paper tissue around your fingertip.

You may prefer to use a blending stump. These are made from tightly coiled rice paper and the shape of the tip makes it ideal for blending smaller areas.

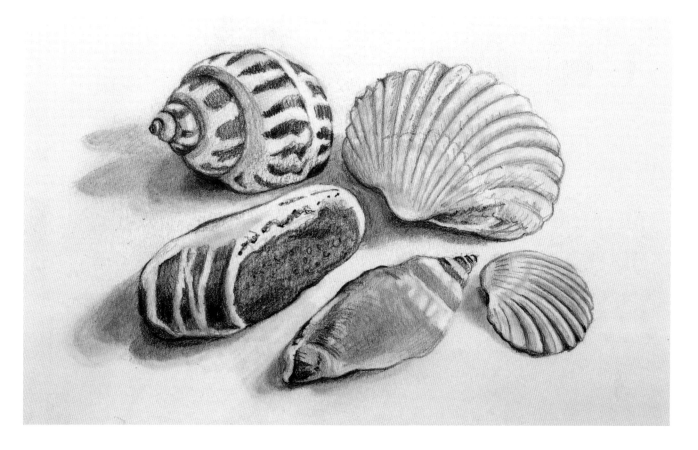

STAGE 4

Now add the deepest shadow areas and darkest tonal values. You will need to look carefully at the shells to identify these and keep working gently to build up and achieve the desired depth of tone. Compare areas of tonal value on the shells and in the shadows that they cast, then look at each area of the drawing to decide if it should be lighter, darker or about the same as other areas. If darker, use a soft pencil to deepen these areas; if lighter, use the eraser to refine any areas of the drawing that are too dark. It should be fairly easy to rub out the pencil, as long as you have built up the tone gradually and not pressed too hard in the previous stages.

Once you have rubbed out areas that should be light in tone, if these areas are too white, add in light tones using the soft pencil with gentle pressure, or use the tissue or paper stump to apply some graphite to these areas. Lastly, you may wish to look for any bright white highlights, which you can pick out using the eraser (see inset).

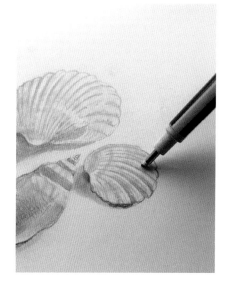

An eraser is a useful tool for creating highlights and lighter areas of tone. A block eraser is a bit clumsy for this task, so you may want to invest in a pen-style eraser for more detailed and accurate rubbing-out.

A tonal drawing consists of a range of tones from white, through various shades of grey, to black. By starting with a mid-tone grey, created by applying your drawing medium – charcoal or graphite – evenly over the drawing surface, you are starting your drawing halfway between black and white. You can build up tones that are darker than this ground with additive drawing; by subtractive drawing, using an eraser, you can create the range from mid to light and, of course, white.

Laying a Ground

Instead of starting with a clean, white sheet of paper – which can be a little intimidating sometimes – you can lay a mid-tone ground and then use what is known as 'additive and subtractive drawing' to make darker and lighter tones. This is explored in the White on White project that follows (see page 34), and in Kitchen Utensils (see page 54). You can lay a ground using charcoal or graphite.

Charcoal ground

For a charcoal ground, you will need some willow charcoal and a cotton wool ball. Lightly apply the charcoal to the paper, then rub it in using the cotton wool ball. Rub using a circular motion, pressing the charcoal into the grain of the paper (**1**). Aim for an even application of charcoal. You will probably have to add more on top of the first application, building it up gradually to produce a medium tone.

Once you have an even ground with a medium tone, you can work into it using either natural or compressed charcoal – or both – or create highlights with an eraser. This is shown below (**2**), from top to bottom: a stick of willow charcoal will make dark grey marks that are easily corrected by rubbing in to the ground using the cotton wool or a paper stump; for darker marks, use a stick of compressed charcoal, which is more difficult to correct, or a charcoal pencil, which can be sharpened to produce finer marks and details; a white charcoal pencil can be used for lighter marks but will mix with the ground, becoming light grey; for lighter tones, use a putty rubber; and for removing the charcoal and revealing the white paper beneath, creating finer details and highlights, use a battery-operated eraser.

1

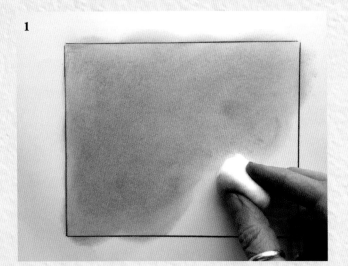

2

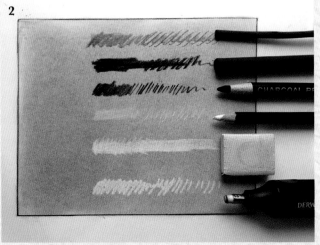

1

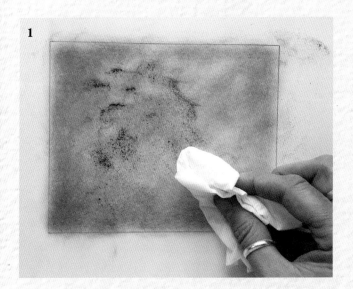

2

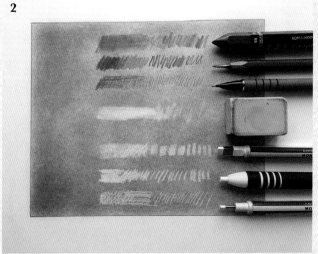

Graphite ground

To lay a ground using graphite, you can use the same method as for the charcoal, this time using a soft pencil and lightly rubbing the side of the lead onto the paper's surface, then rubbing it in. An easier method, however, is to use graphite powder. Sprinkle a little of the powder onto the paper and disperse it as evenly as possible by stroking it over the paper's surface using the edge of a tissue, then rub it in gently with the tissue, using a circular motion and not too much pressure (**1**). For an even result, it is best to build it up gradually.

With graphite, you can create finer, more detailed marks. This can be seen above (**2**), from top to bottom: a soft grade of graphite stick, such as a 6B, is great for drawing bold, dark strokes, while a conventional pencil can be sharpened for more detailed work; a fine, medium-grade pencil will create fine details; a regular eraser can be used to rub out broad strokes and large areas; pen erasers of different shapes and widths are perfect for drawing pale marks and revealing the white paper for sharp highlights.

Tip
It is better to build up the ground gradually, or you may end up with one that is too dark. Aim for a medium grey tone with a smooth, velvety texture.

You can buy graphite powder, but there are several ways to create it yourself. You can buy a purpose-made pot with a small grater in the lid: rub the graphite across the grater and the powder will drop into the pot; then, if you tip up the pot, you can dispense the powder onto your paper through the holes in the grater. You can also buy a 'sprinkler', which consists of a little rectangular frame with a metal mesh: rub a graphite stick across the mesh and it will create graphite powder. You could also use a sandpaper block or emery board. Whichever process you choose, try not to create too much dust as it can be harmful to breathe it in. If you are going to use this method regularly, you may be wise to wear a mask.

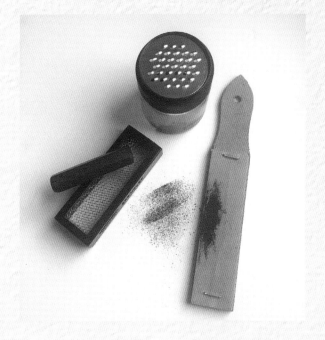

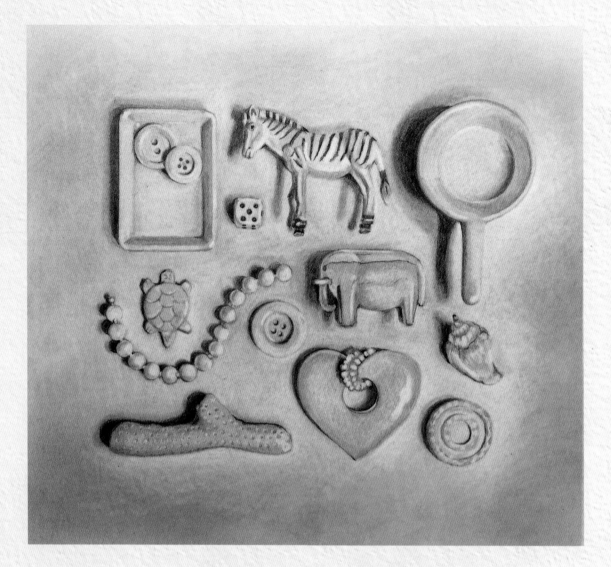

White on White in Graphite

Drawing a selection of small objects that are mainly white will help you
to develop your ability to differentiate tones because, without the distraction of colour,
it's possible to see tones even more clearly. You will begin by laying a ground using graphite,
then create a tonal drawing using two drawing tools: a pencil and an eraser.

YOU WILL NEED
graphite pencils: 2B or HB and 4B or 6B
graphite powder • tissue or cotton wool ball • blending stump
pen eraser • heavyweight cartridge paper

Many inexperienced artists can feel daunted when faced with a blank sheet of paper: a large expanse of white can be a bit of an obstacle and it can be difficult to know where to make the first mark. By laying a ground (see page 32), you are removing this obstacle before you begin drawing because you are starting out with a mid-tone, instead of white. You will be able to use a pencil to create tones that are darker than this mid-tone ground, and for tones that are lighter, you can use an eraser to expose areas of the white paper. These white areas can be left as highlights; or they can be worked into with the pencil, or by rubbing in a little more graphite, using a tissue or a paper stump, to create light to medium tones.

For shading and creating areas of dark tone, I suggest using a 4B or 6B pencil, which is soft, dark and easy to smudge and blend. For finer, crisper lines, I find that a 2B pencil is a good choice, but you might find you prefer an HB, which is slightly harder. It is a good idea to test a few pencils on a scrap of paper before you begin drawing, so you can choose which suits you best. Whatever you use, aim to create a drawing that has white areas, black areas and a good range of tones in between.

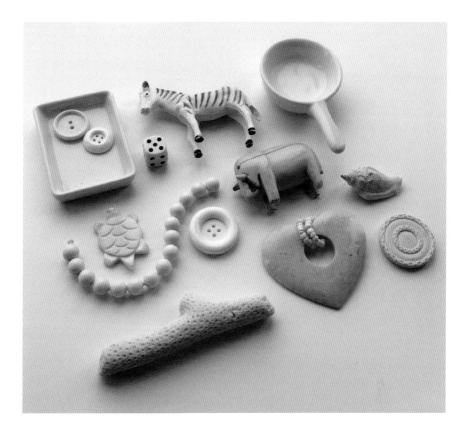

Setting up

Select some small white or off-white objects and arrange them in a formal pattern on a piece of white paper. Because this is going to be a tonal drawing, you want to create some light and shade in your still life. To do this, place the paper near a window or, if this is not practical, use an artificial light source such as a lamp. Aim to create shadows to one side of the objects; in this case, the light is coming from the top and right, creating shadows on the left side. Because the objects are sitting on a white surface, the shadows are clean and easy to distinguish. You may have to place your arrangement on a low table or on the floor, so you can look directly

down at it; you will be concentrating on the shapes and the range of tones, so we will choose an overhead viewpoint, which more or less eliminates perspective.

Try to include objects that have an interesting shape, such as the elephant and zebra, shown above. Choose some items that are round and some with straight sides; some that have a smooth, reflective surface, such as the little china dishes; and some with a rougher texture, such as the carved turtle, the seashell and the twig-like object, which was found while beachcombing, and could be a fossil or piece of bone. And try to include things with holes in them, like the buttons and the heart, so that you can observe the way shadows form inside the shapes.

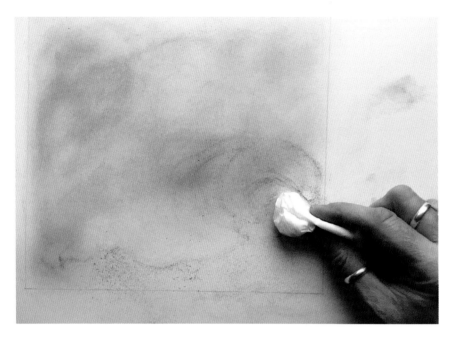

STAGE 1

Mark out a rectangle on your paper. This will be your picture area and should include a wide margin around the objects to allow for trimming when the drawing is complete. Fill this area with the graphite ground, sprinkling the paper with a light dusting of graphite powder and rubbing the powder into the surface of the paper in a circular motion, using a cotton wool ball or crumpled tissue. Aim to create a medium-light ground for this subject.

STAGE 2

Using an HB or 2B pencil, mark out the shapes of the objects. Look at the overall shapes and the general shapes of the cast shadows, as this will help you to get the spaces between the objects correct. Keep the marks light – you will be refining them and removing some at a later stage. To prevent smudging, place a piece of scrap paper over areas you are not working on (see inset). Of course, it is best not to rest your hand on your drawing – by holding the pencil shaft towards the blunt end, instead of the point, you will find you have freer movement.

A clean piece of paper laid on top of your drawing will not only prevent smudging and help to keep your hand clean, but it will also help to prevent greasy marks being transferred from your skin onto the drawing.

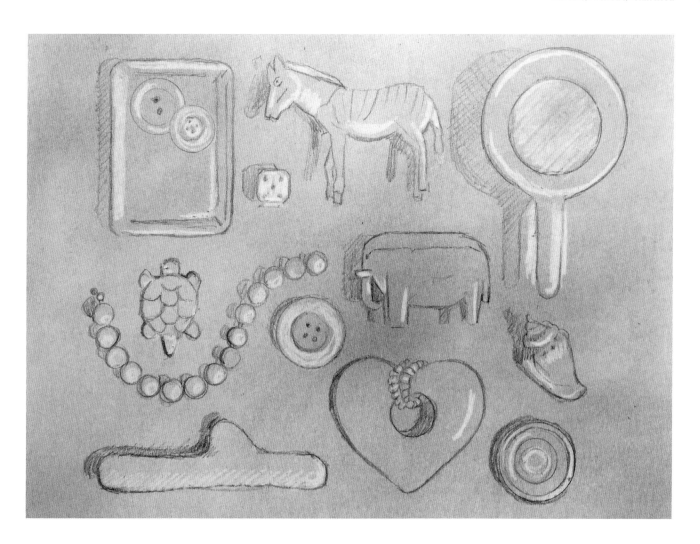

Use a pen eraser for creating highlights and lighter areas of tone. Unlike a regular eraser, because it has a fine point it can be used for detailed and accurate rubbing-out. Think of it like this: while a graphite pencil is a drawing tool for creating grey and black marks, a pen eraser is a drawing tool for creating white and light marks.

STAGE 3

Still using the HB or 2B pencil, refine your initial marks until you are happy with the shapes and placement of the objects. You needn't worry about fine details at this stage. Now swap to using the pen eraser and use this to draw lighter areas and highlights (see inset).

At this early stage of the drawing, it is a good idea to get used to using both tools: the pencil when you want to draw a mark that is darker than the ground, and the pen eraser for marks that are lighter than the ground. Rather than putting it down and forgetting to use it, hold the tool you are not currently using in your non-drawing hand, ready to swap over.

Tip

Remember to sharpen your pencils from time to time, as a blunt pencil will not be so effective in drawing detailed marks. Similarly, if the eraser becomes covered with graphite it will be much less effective at rubbing-out. Try rubbing it on a spare piece of clean paper, or trim off the tip with a craft knife.

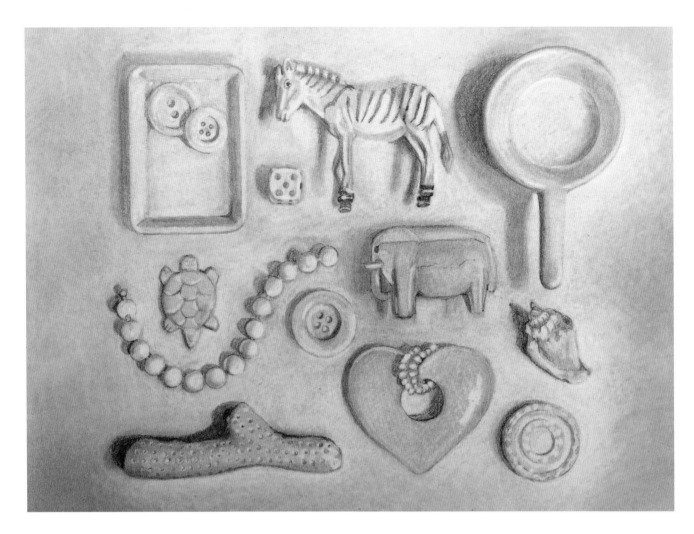

STAGE 4

Now look carefully at your still-life arrangement for variations in tone. Use a 4B pencil or a 6B, or both, to build up the tone, stroking the side of the lead across the surface of the paper to increase the tonal value gradually and using the point of the pencil for details. Use a harder pencil – 2B or HB – for finer details. At the same time, don't forget your other drawing tool: the pen eraser. Remember to swap from pencil to eraser frequently, building up both dark and light areas. If you erase too much, you can add more tone, either with the pencil or with some more graphite powder. Use a blending stump for small areas (see inset) or a cotton wool ball or tissue for larger areas.

Build up your drawing by strengthening some of the tones and lightening others. Compare areas of tonal value on the objects and in the shadows that they cast, then look at each area of the drawing to decide if it should be lighter, darker or about the same as other areas. If darker, use your soft pencil to deepen these areas; if lighter, use the eraser to refine any areas of the drawing that are too dark. It should be fairly easy to rub out the pencil, as long as you have built up the tone gradually and not pressed too hard in the previous stages.

To create light tones in erased areas, pick up some graphite from a darker area of the drawing, or from your pot of graphite powder, on the tip of a blending stump. The blending stump now becomes yet another mark-making tool.

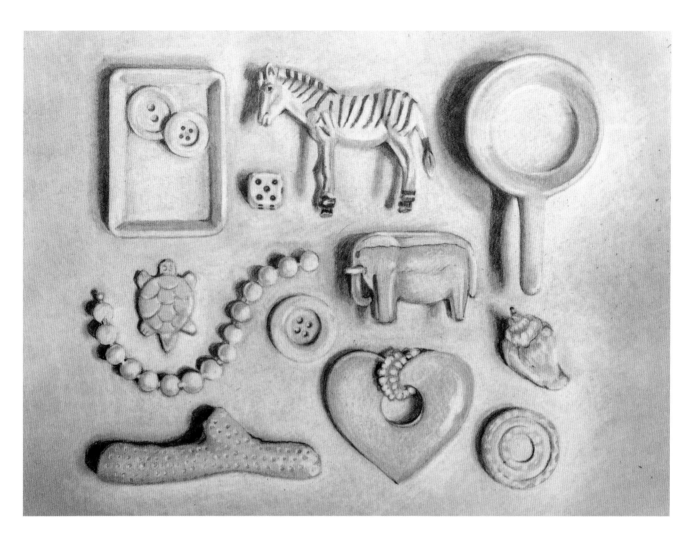

STAGE 5

Continue building up all areas of the drawing. In my experience, many students reach stage four and stop. They worry that if they go any further, they will spoil what they have achieved so far. They often need to be persuaded that the finished drawing will be more effective if it contains not just a range of light and medium tones but also white highlights to add light and sparkle, and black shadow areas to create depth and drama.

So, don't neglect these finishing touches. Look at the overall arrangement to identify the lightest lights and the darkest darks, then focus on each object in turn to judge exactly where to place them.

When you are happy with your drawing, you may wish to clean up the edges around the pencil outline you drew at the beginning (see inset). However, if you intend to frame the drawing, there is no need to do this because the untidy edges will be covered by the card mount or hidden by the frame.

A pen eraser with a square tip is the ideal tool for cleaning up the edges of your drawing. Place a ruler along the margin of the drawing, as a guide, then run the eraser tip along the ruler to remove smudges of graphite and create a crisp edge.

FOCUS ON

Negative Space

A still-life picture is not just about the solid forms – the named objects in your arrangement – but also the spaces that are between these forms, which are known as 'negative space' or 'negative shapes'.

Practise looking for negative space by sketching various arrangements of objects. It will help if they are placed on a flat surface, against a backdrop, fairly close together and overlapping. Look for the spaces between the objects, shapes within the objects – such as the gaps inside handles on cups and jugs – and those between the objects and the horizontal and vertical surfaces.

Negative shapes are just as important as the objects in your still-life pictures because they contribute to the overall composition. What's more, by recognizing, observing and describing these shapes, they help you to draw more accurately.

When you draw a familiar object, the problem is its familiarity. It's a struggle between what you see and what you know – or think you know. By drawing the negative spaces, we are seeing shapes we haven't seen before, so we are looking at them afresh. If you are a beginner, it may take a while to understand this concept and to accept it. It may also be difficult to look at a subject and to identify the negative shapes.

Identifying and drawing negative shapes

Try this exercise with a flat arrangement. I suggest using leaves, as they are easy to obtain and have interesting shapes. Trim off the stalks so that the leaves lie reasonably flat. Ivy leaves have been used here.

1 Place the leaves on a piece of A5 (8⁵/₁₆ x 5¹³/₁₆in/210 x 148mm) coloured paper. Try to arrange them so that parts of the leaves touch the edges of the paper and each other. Place the arrangement on a white surface so that you can see the edges of the coloured paper clearly. For the first part of the drawing, you will need a medium-grade pencil, such as an HB or B (see page 10).

2 Draw your picture format – in other words, the shape and size of the coloured paper – in the centre of a piece of A4 (11¹¹/₁₆ x 8⁵/₈in/297 x 210mm) cartridge paper. Now start drawing. You are not drawing the leaves themselves but the shapes between the leaves: the pieces of exposed coloured paper. You will see that the edges of the A5 paper are the edges of some of the negative shapes. Draw light marks at first, without too much pressure on the pencil, correcting as you go along.

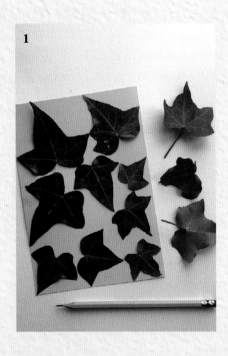

1

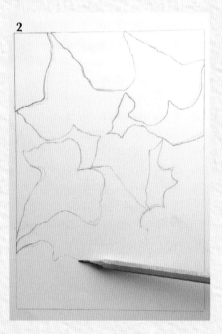

2

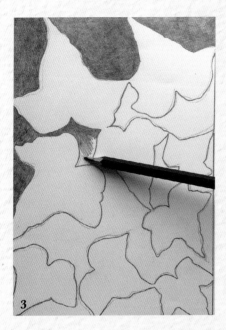

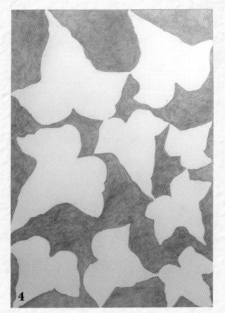

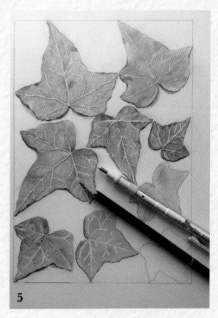

3 Keep going until you are really sure that the shapes you have drawn are accurate. As you become more confident with the drawing, you can go over the lightly drawn lines, correcting them and reinforcing them as you go. If you like, you can swap to a softer grade of pencil, such as a 4B, which makes darker lines. When you have finished drawing all the negative shapes, you could begin to colour them in, shading with the soft pencil.

4 Once all the negative spaces have been filled in, you should be able to clearly see the balance of the composition and the importance of these shapes in the overall picture.

5 Another option is to draw the negative shapes, as before, then add the details on the leaf shapes that have emerged between the spaces, to complete the drawing. Observe these carefully, noting that the leaf veins are lighter in colour – an eraser pen will come in useful here. Even though the leaves are lying flat, they will still cast a small shadow under the edge furthest away from the light source.

Now you have practised on a flat arrangement, get into the habit of looking around to identify negative shapes in everyday set-ups. You can arrange some items, or just look around your indoor space for existing groups of objects. You can also look for negative shapes in photographs; flick through the pages of a magazine to find examples. Make sketches of any arrangements that you find interesting. Outline any negative shapes you can identify – you don't have to colour them in, but you may find it useful to do so.

These exercises will help to train your eye and make you more observant, so that when you come to draw or paint a still life, recognizing and drawing shapes more accurately will become second nature.

Tip
Negative spaces in more complex arrangements will occur between objects, within a single object – such as the gap between the edge of a cup or jug and its handle – and between the outlines of objects and the surface they are sitting on, the background, and the edge of your picture format.

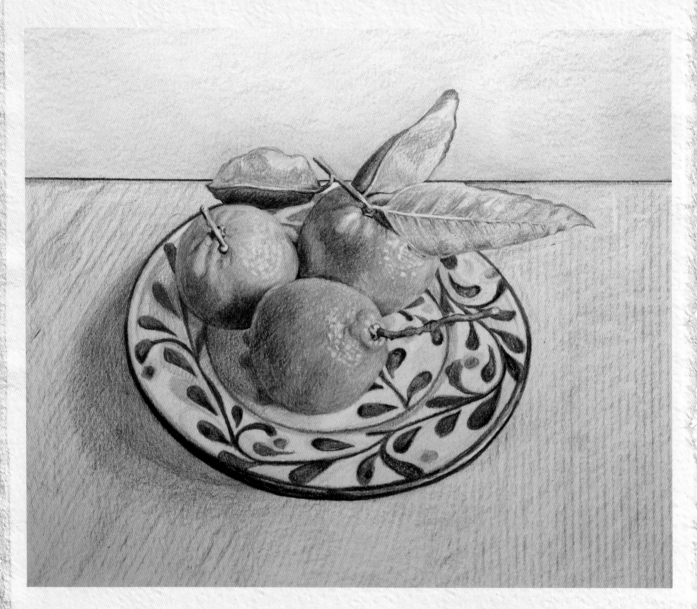

Oranges in Coloured Pencil

Here, we will be introducing colour to your still-life repertoire, using coloured pencils. Fruit and vegetables are a perennial favourite for still life, as they have plenty of colour, texture, shape and form to get to grips with. These three oranges have been chosen because of their lovely bright colour and because they still have their stalks and leaves intact, which provide added interest.

YOU WILL NEED
graphite pencil: 4B • coloured pencils: colours to match oranges,
plate and table • eraser • large sheet of heavyweight cartridge paper
corrugated paper or card • easel (optional)

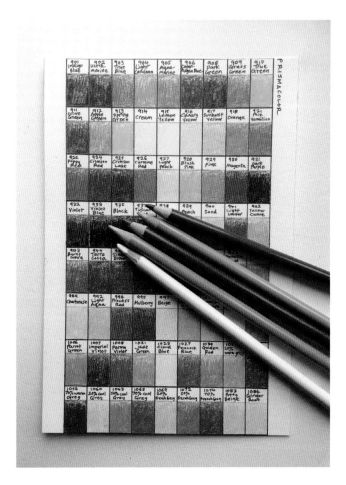

Tip

This drawing will be done on white cartridge paper, using the white of the paper for the highlights. Choose a reasonably large piece of paper, as it is difficult to achieve fine detail when working on a small scale. The picture area of this drawing is 10½ x 8½in (26.5 x 21.5cm).

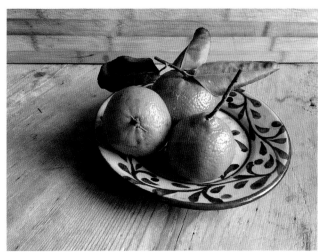

Coloured pencil is an ideal medium for the inexperienced artist. It's a good idea to try out all your pencils on a spare piece of paper so you can select the best ones to use for this project, as you'll find it's difficult to judge the colour just by looking at the pencil or by consulting a printed colour chart.

In fact, it is worth spending time to make your own chart that shows the colours of all the pencils in your set. Do this by drawing a grid on a piece of paper that will fit into the box where you keep your pencils, so you will always have something to refer to (see above). The grid should be made up of small sections, one for each pencil and perhaps a few extra blank sections for when you add to your collection.

Setting up

Choose a small or medium-sized plate with a simple pattern and place it on a tabletop or a wooden board. Place a second board, or a piece of stiff card, behind the plate, to form a plain backdrop. Arrange your fruit on the plate. I have placed these oranges on a plate with a blue pattern because orange and blue are complementary colours (see page 22). If you prefer to draw some red apples, you might like to choose a green plate; for yellow pears or lemons, a violet plate; for green apples, a red plate; and so on (refer to the colour wheels on pages 20–21).

Make sure the light is coming from one side, to create clear shadows. The subject shown here is lit with natural light coming from a window to the right, creating a cast shadow on the horizontal surface and some good shadows and highlights on the fruits and on the plate.

The viewpoint for this drawing is three-quarters. There are three main viewpoints for still life: overhead, straight on and three-quarters (see page 25). The latter is a good choice for a food subject because it looks natural: this is how we view food when we sit down to eat. A three-quarter view is any angle between about 25 and 75 degrees, so do experiment with a few different viewpoints before settling on your final choice. The placement of your arrangement will also depend on light conditions and on whether you are drawing standing up at an easel or sitting down at a desk.

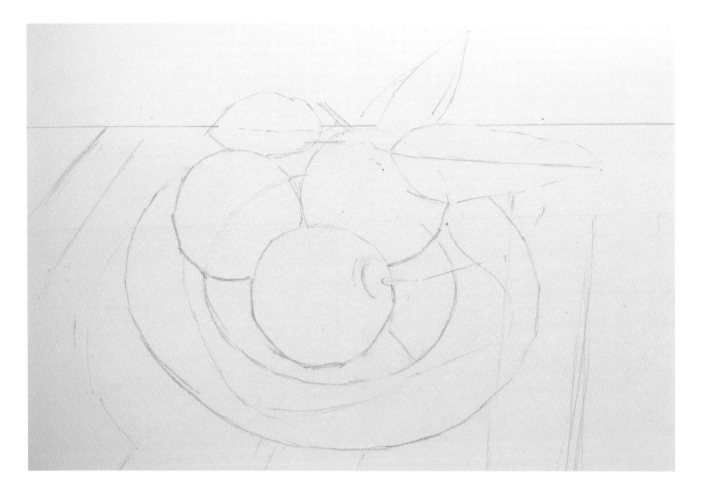

STAGE 1

Use a 4B pencil to sketch out the basic shapes. Draw the horizon line – the back edge of the horizontal surface – above the centre of the paper and use this line to help you position the other elements of the drawing. Placing the plate of oranges centrally creates a calm composition. Look carefully to see where the horizon intersects the back edge of the plate and the leaves. Also look for negative shapes between the fruits, stems and leaves; between the edges of the fruits and the shape of the plate; and the spaces on either side of the plate. Use light pressure to make this initial drawing so that some of these marks can be erased at a later stage, if required. Once the marks have been covered with layers of coloured pencil they will be difficult, if not impossible, to remove. Look for highlights on the oranges and on the plate and use a white pencil to draw these, using a bit of pressure (see inset). Make sure the white pencil has a sharp point.

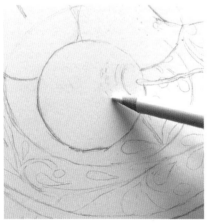

Use the sharp tip of the white pencil to create highlights. Use a bit of pressure so that you make dents in the paper. This is known as incising. When you shade the area with colour, the coloured pencils will skim over the surface of the paper, leaving the dented areas untouched.

Tip

As you gain confidence, you will become less reliant on preliminary drawings. You will also, hopefully, become less worried about the finished result and more absorbed in the process.

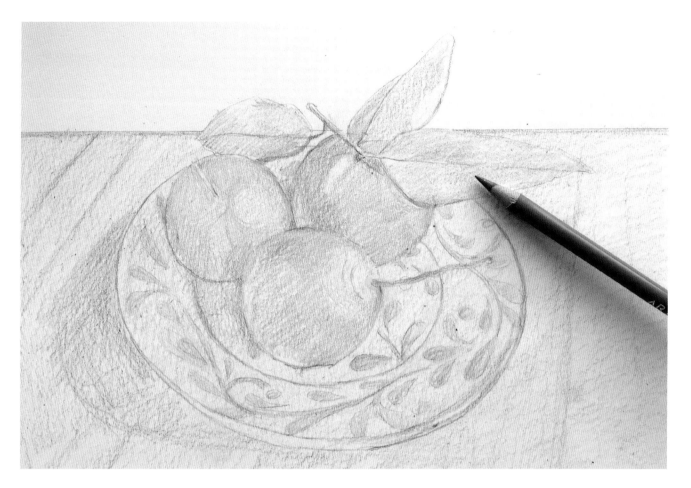

STAGE 2

When you are happy with your initial drawing, block in the large areas of colour. Aim to cover the whole picture area; don't concentrate on any details at this stage. I used Tuscan sun for the oranges; matcha green for the leaves and stalks; sienna brown and camel brown for the table's surface; and forest green to indicate main areas of shadow. For the plate, I used sky blue all over and to indicate the general painted patterns. (Colour names will vary between different brands of pencil.) When shading these areas, use the side of the pencil and very light pressure, particularly in the lightest areas and highlights (see inset).

Tip

Pencils need to be sharpened regularly as your drawing develops, as the best-quality soft-core coloured pencils wear down quickly and soon become blunt. Use a knife or pencil sharpener, according to your personal preference. A sanding block is also useful for refining pencil points (see page 16).

When blocking-in colour, try to use light pressure and the side of the pencil, holding it with a loose, overhand grip (see page 18). It helps if the pencil lead is quite long.

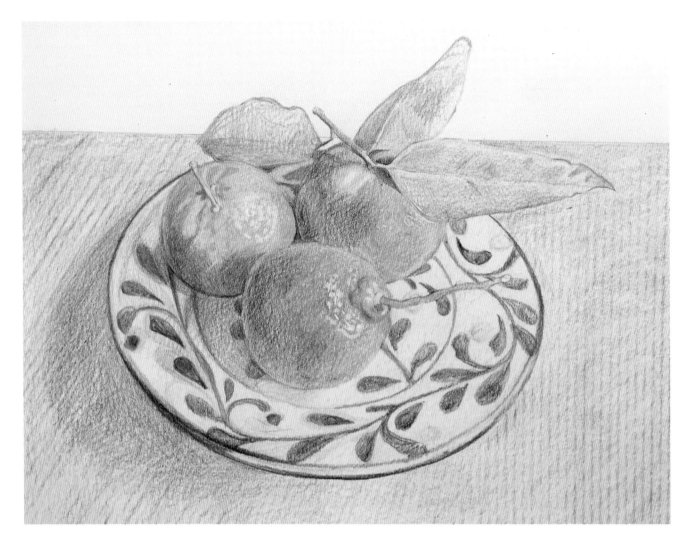

STAGE 3

Build up the colour slowly, with light applications of the pencils. This includes the shadow areas, where you will need to overlay layers of different colours to create darker tones. On the oranges, add some lighter and darker shades of orange pencil – sunflower yellow and orange – and use ultramarine blue in the shadow areas. Blue, when laid over areas of orange, creates a sympathetic neutral colour for realistic shadows. Develop a medium level of tone and colour all over the picture area.

Placing your paper on top of a textured surface, then rubbing your pencil lightly over the surface of the paper will pick up the texture beneath. This method is known as frottage, from the French verb frotter, meaning 'to rub'.

Don't neglect the surface of the table or board on which the plate sits; it is just as important as any other element of the picture. Rather than spending too much trouble on the detail of the wood, however, try a shortcut: place a piece of corrugated paper under your drawing paper and lightly shade over the whole area. I used camel brown for this. The pencil will pick up the lines of the corrugated paper. Where necessary, change the angle of the paper for the different areas of wood so the lines of corrugation follow the lines of the wood grain.

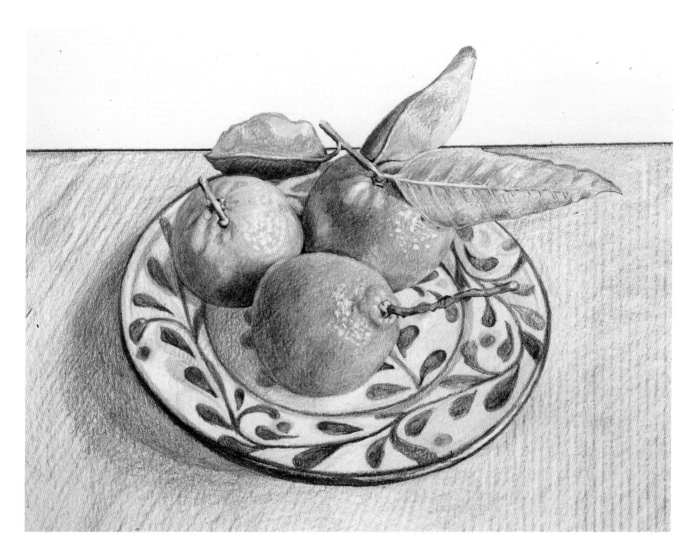

STAGE 4

Carry on adding light layers, deepening the tones and strengthening the colours all over the drawing. Then look for the darkest areas, such as the point where all the oranges touch, and make sure these areas are dark enough. You may choose to use black for this but use it very sparingly. For the best overall effect, you should have white highlights and some deep, dark areas of tone, as well as a good tonal range overall.

For adding details, make sure that your pencils are sharpened, and use the point of the pencil, still building up colour and tone with light pressure, not pressing too hard. Think of details as small shapes within shapes and try to avoid adding outlines where there are none. For darker areas on the leaves, basil green and jade green can be used; these two shades are also useful for adding to the general shadow areas.

You can leave the drawing as it is at the end of stage 4, with the top third of the paper untouched, providing a clean white backdrop. If you prefer, however, you can colour in this area with a plain colour, as I have (see page 42); blue is a good choice, as it contrasts well with the oranges.

Just as there is blue in the shadows on the oranges, there are touches of orange reflected on the shiny surface of the plate. Try to search out these areas and colour them accordingly.

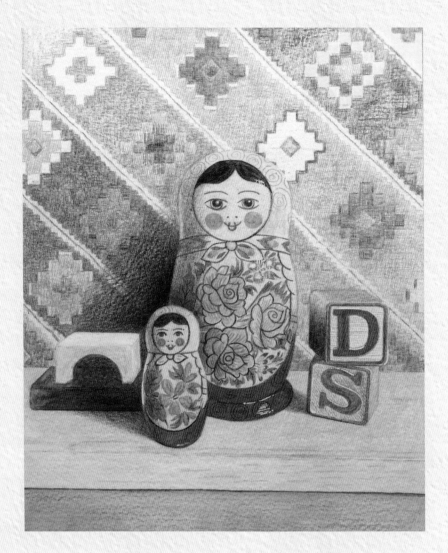

Toys on a Shelf in Watercolour Pencil

Traditional painted wooden toys are an excellent subject for still life – they are smooth, shiny, colourful and, in the case of these Russian dolls, richly patterned. To depict the textures of these toys, the fabric background and the wooden shelf, watercolour pencils are the ideal choice: they work like coloured pencils but transform into paint when water is added.

YOU WILL NEED

graphite pencil: HB or B • watercolour pencils: colours to match toys, shelf and fabric • white paint pen or gel pen • tissue • eraser round paintbrushes: sizes 6 and 2 • cold-pressed watercolour paper (Bockingford) • drawing board • drawing pins, board clips or masking tape • easel (optional)

Tip
Good-quality watercolour pencils
are soft and wear down quickly,
so make sure you sharpen them
regularly while you work.

Setting up

The viewpoint for this picture is eye level, so try to set up your arrangement on a raised platform, such as a table or chest of drawers. If you are going to be doing a lot of still-life pictures, it is worth having a small stock of painted boards and backdrops in different colours. You can even cover some boards with patterned wallpaper or fabric. Experiment with different surfaces and backdrops, and with various arrangements of objects, until you find a combination you are happy with. I tried both a plain and patterned backdrop and decided to go with the colourful fabric, with the toys lined up on a yellow painted board on top of a blue painted stool, providing lots of colour and texture.

Attach the paper to your drawing board using drawing pins, board clips or small pieces of masking tape, and sit with the board propped up or placed on an easel.

Watercolour pencils are excellent stepping stones towards watercolour painting because they are applied dry, so you have more control. They look and feel very similar to standard coloured pencils, the difference being that, once water is applied to the marks made by watercolour pencils, the pigment dissolves and becomes more like paint. The process smooths out the pigment on the paper and you can transform rough, textured marks into smooth areas of coloured wash. Watercolour pencils also allow you to be selective, choosing which marks to soften and blend with water and which to leave untouched.

As suggested on page 43 for coloured pencils, it's a good idea to create a colour chart of all your watercolour pencils so you can refer to them as you work, helping you to select the most appropriate colours. On a piece of paper, draw a grid that has a section for each pencil. Colour in each section and dampen a small area of each colour to see what it looks like when water is added.

However, no matter how many watercolour pencils you have, it's likely that you'll struggle to find an exact match for some of the colours. If that's the case, you can use two or more colours to achieve the one you are looking for. Test out these mixes on the margins of your paper, or on a spare piece, adding a little water to see what they will look like when they are dissolved.

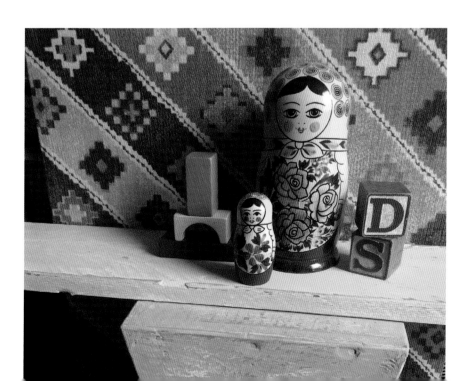

Tip

Having played around with different arrangements, I decided to remove the green brick before beginning the foundation drawing. Being sure of your composition right from the start is important, so experiment with positioning the various elements before you commit your composition to paper.

For the repeat pattern on the fabric, why not cut out a small paper template to use as a stencil? You can position this on the paper and draw around the outline using a pencil. Another way to use this template is to lightly shade around the edges of it, onto the surrounding paper, using a watercolour pencil in the appropriate colour.

STAGE 1

Using an HB or B pencil, lightly sketch the foundation drawing. A mechanical pencil is ideal for this, as it creates a thin, unobtrusive line. Draw the overall shapes of the objects, including the shelf and the backdrop, overlapping lines if necessary, to get the shapes right. Remember to look for negative shapes in the spaces in between (see page 40).

Think about the format, deciding whether you want the picture to be horizontal (landscape), vertical (portrait) or square. When I was setting up this still life, I decided that I wanted it to be formal, quite symmetrical and balanced, which I felt would suit the subject. Once you have decided on your composition, draw an enclosing box using a ruler and pencil. The format I have drawn is portrait and measures 10 x 8in (approximately 25 x 20cm).

There is no need to draw in any shadows or tone at this stage.

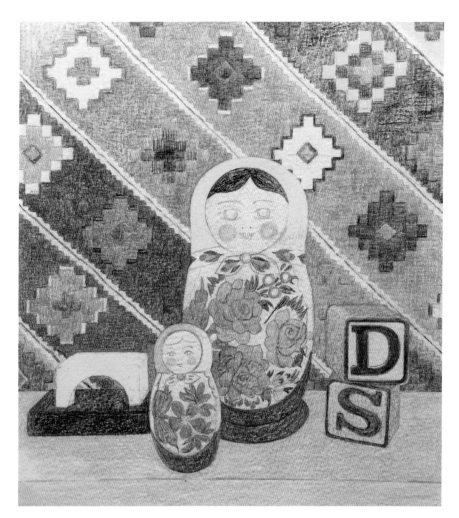

If necessary, combine two or more pencils to obtain the colour you want. For pale tints, apply the pencil very lightly.

STAGE 2

Now colour in the shapes you have drawn, building up the colours gradually and referring to your colour chart for accurate colour matches or creating mixes from two or more pencils (see inset). Lighter colours are particularly challenging. When you look at your colour chart, most of the colours will appear too bright. In that instance, try applying the pencil very lightly, to make a lighter tint. Test it on spare piece of paper, adding water, and experimenting to find the right colour. You will see from your swatches that, once water is added, the colour will intensify; therefore, it's better if it's a little too pale, as you can always add another layer once the first has dried, but if it's too dark, it will be difficult to rectify. When colouring in the fabric backdrop, try shading horizontally and vertically, so that your coloured pencil strokes resemble the weave of the fabric (see inset).

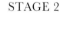

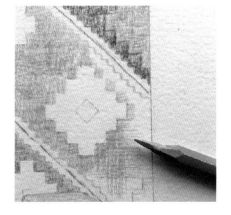

When colouring in the fabric backdrop, try shading horizontally and vertically so that your coloured pencil strokes resemble the weave of the fabric. Build up the colour gradually and use two or more different pencils, if necessary, to obtain a good colour match.

Tip
Have an eraser handy because, as you begin to add colour, you may wish to soften or completely remove some of the underlying pencil lines.

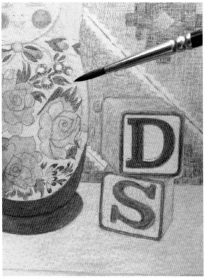

STAGE 3

Once all the shapes have been filled in, it is time to add some water. Decide in which areas you wish to blend the pencil marks – in this case, it is the painted wooden toys and the wooden shelf that need to look smooth and polished, while the backdrop of woven fabric will be left as it is. Wash over each area in turn, using a size 6 round brush and clean water (see inset). The water will dissolve the pigment and soften the pencil marks. The brush shouldn't be too wet: dip it in clean water, then blot it on a paper tissue before applying it to the drawing. Wash out the brush in clean water each time you move on to another area, or the colours will become mixed and might end up looking muddy instead of fresh and bright. Leave the drawing to dry completely before moving on to the next stage.

A good-quality round brush will come to a fine point. You should be able to use the belly of a size 6 brush for painting larger areas and the tip of the brush for fine details – but if you find this difficult, use a smaller brush.

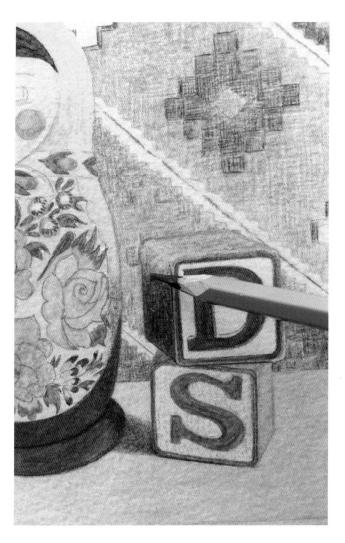
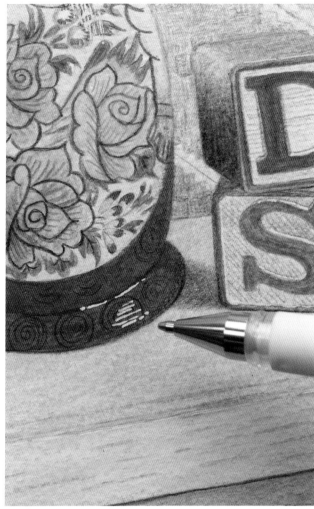

STAGE 4

When the painted areas are dry and you are happy with all the colours and the overall balance, it is time to add shadows. Choose a dark grey pencil and look carefully at your set-up to see where the shadows fall. Notice any variations in tone within the shadow shapes: the darkest areas will be close to the objects; there will also be a few reflections from nearby objects. There will also be a dark line underneath the objects, where they are sitting on the horizontal surface.

Start filling in the shadows with a light touch and build them up gradually. Use a scumbling action – that is to say, use the tip of the pencil and move it in different directions, in a kind of circular motion, like scribbling. Because you are working on a textured paper, and on top of a previous layer, it can take time to build up a smooth area of shadow, filling in the little dips and dents of the paper – but be patient and methodical, and don't be tempted to press too hard.

STAGE 5

Once you have completed the shadows, put in any final details – in this case, the facial features and the outlines of the painted designs on the bodies of the two dolls. For these details, you won't be adding water, so you could use a standard coloured pencil in place of a watercolour pencil, choosing one that sharpens to a fine point. On the actual dolls, these outlines have been painted in black, but you should exercise caution when using black in your coloured drawings, as it has a tendency to dominate. Try a dark grey pencil first, and swap to black only if you feel you need to. Finally, put in any white highlights, using a white paint pen or gel pen.

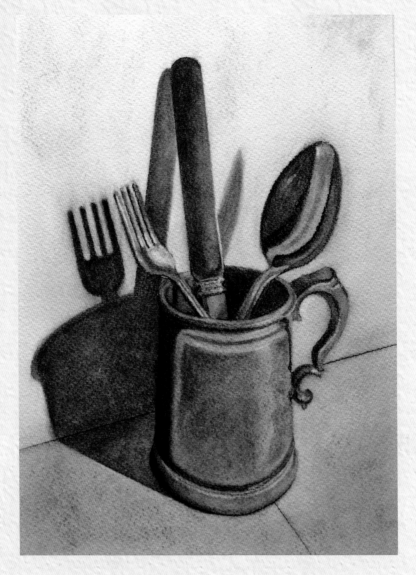

Kitchen Utensils in Charcoal

In this tutorial you will practise creating a tonal drawing using charcoal. Metal objects are an ideal subject for tonal work because they are smooth and reflective, and charcoal is very forgiving – you can easily smudge or erase marks – but be prepared to get your hands dirty in the process.

YOU WILL NEED
charcoal pencils: light and dark • willow charcoal: thick and thin
blending stump • tissue or soft cloth • putty eraser • battery-operated
eraser • large sheet of cartridge paper • drawing board • drawing pins,
board clips or masking tape • easel (optional)

Tip
A large piece of paper is recommended because it is difficult to achieve detail with charcoal when working on a small scale.

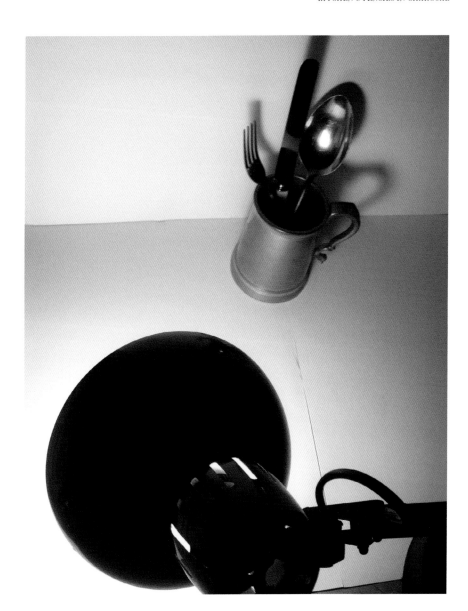

You will be using both natural and compressed charcoal for this drawing. The natural charcoal – willow – is useful for laying a ground (see page 32) over large sections of the drawing and producing a foundation in a range of mid-tones. Compressed charcoal produces crisper, darker marks, which are perfect for adding firmer lines and areas of deeper shadow and details. In this project, a light charcoal pencil is used for the initial drawing and a dark one for drawing details in black.

The drawing will be done on white cartridge paper, using the white of the paper for the highlights. The paper should not be too smooth; charcoal requires a paper with a surface texture – known as 'tooth' – that will trap the fine dust particles. A paper with a good tooth will hold more charcoal, allowing you to build up darker tones. If the surface of the paper is too smooth, the charcoal dust will just slide off the paper. For example, either a good-quality cartridge paper or a cold-pressed watercolour paper that is not too rough, will provide the right kind of surface.

In this project, you will also use an eraser as a drawing tool. Several types of eraser are useful when working with charcoal. Here, I have suggested using both a putty eraser and a battery-operated eraser.

Setting up

For a tonal drawing, it helps if the subject includes plenty of light and shade. The set-up shown here, with a good degree of direct light on the subject, and dramatic cast shadows on the horizontal and vertical surfaces, is ideal.

Select some items of metal cutlery – a knife, fork and spoon – and arrange them in a container. The cutlery shown here has been placed in a pewter tankard. Stand it on a white surface and prop up a large piece of white board behind it. Use a lamp to create strong, interesting shadows. In this case, the light is coming from the front and slightly above the objects, creating shadows on both the horizontal and vertical surfaces. Because the surfaces are white, the shadows are clean and easy to distinguish. You may have to place your arrangement on a low table so you can see it from a three-quarters viewpoint (see page 25).

Attach the cartridge paper to your drawing board using drawing pins, board clips or small pieces of masking tape, and sit with the board propped up or placed on an easel.

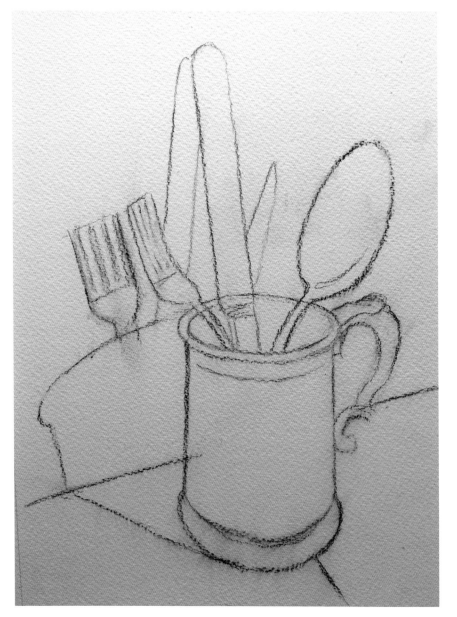

Tip
A light charcoal pencil produces a greyish line, which is perfect for a preliminary drawing. Being made from compressed charcoal, it cannot be easily erased and so the lines will remain, even when adding a ground in stage 2.

STAGE 1

Using the light charcoal pencil, draw the main shapes. This doesn't just mean the outlines of the objects – fork, knife, spoon and tankard – but also the shadow shapes and the line where the horizontal and vertical surfaces meet. In this case, the horizontal surface is covered with two sheets of paper and the line where they meet is also drawn in. Lines such as these help to indicate the solid surfaces, and they also, if you notice carefully where they touch or intersect with the solid objects, help you to draw the correct proportions and outlines. When drawing the top of the tankard, draw the whole ellipse – this makes it easier to draw an accurate shape. Of course, the items of cutlery overlap the back of this shape, but any superfluous marks can be erased or covered up.

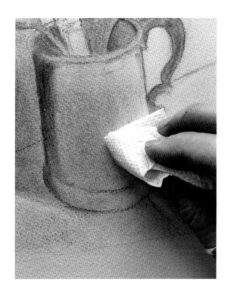

A paper tissue or kitchen towel, rubbed over the charcoal, will push the particles into the tiny indentations in the paper's surface, helping to create a smooth area of tone.

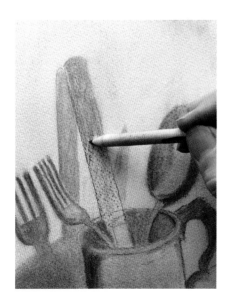

A paper stump is useful for smoothing out the charcoal in intricate areas; rub it over the paper's surface in a circular motion.

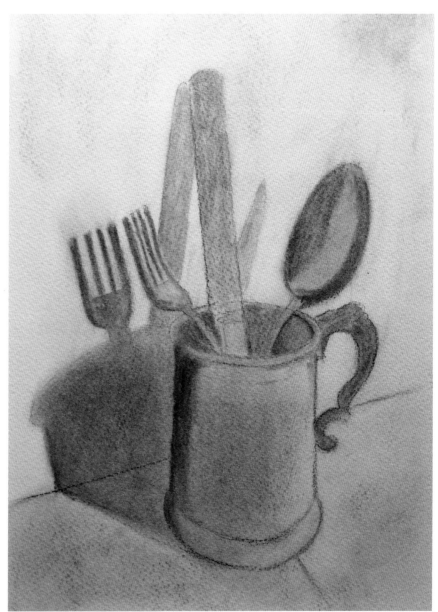

STAGE 2

Lay areas of ground using a piece of willow charcoal. Break off a short length of the stick of charcoal so that you can use the broad side of the piece for larger areas and the tip for smaller areas. Rub the charcoal into the paper using a tissue for broader areas and a paper stump for smaller shapes (see insets). Try to achieve a range of mid-toned areas of ground, looking for lighter and darker tones in your subject and not paying too much attention to very dark areas or highlights at this stage.

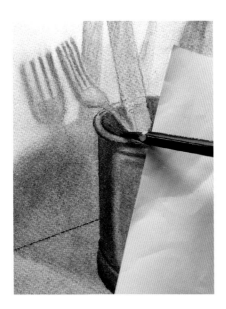

Use a piece of scrap paper to prevent smudging the drawing with your hand as you work.

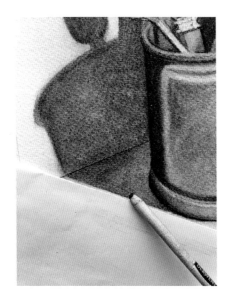

The same piece of paper can be used as a shield when smudging or blending areas of charcoal. It will prevent the charcoal from being transferred into other areas of the drawing and will help you to achieve a neat straight edge, if needed.

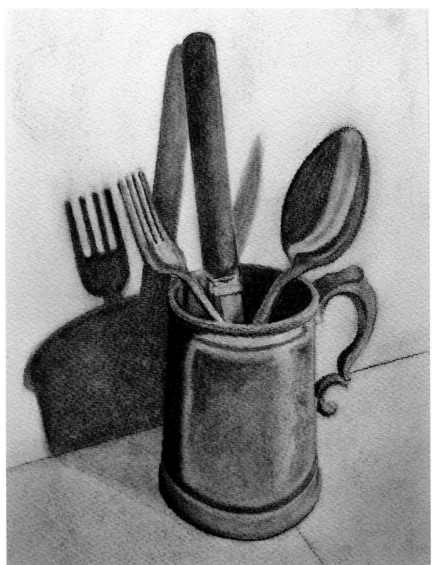

STAGE 3

Now strengthen and deepen the dark areas. Look at the overall set-up to identify where the darkest shapes are to be found: in the cast shadows; on the knife blade; on the bowl of the spoon; between the tines of the fork; inside the tankard; and underneath the base of the tankard, where it sits on the horizontal surface. Concentrate on each of these, judging how much darker they are than the surrounding mid-tone areas. Use a piece of thin willow charcoal for larger shapes, smudging these to create even tones, and applying more on top as necessary.
For finer details, use a dark charcoal pencil, which produces a really dark mark, and blend this with a paper stump. Bear in mind that willow charcoal is very easy to soften and blend, while the pencil, with its compressed lead, is more difficult to blend and much more difficult to erase.

Tip
As the putty rubber becomes grubby it will be less effective. Pull it apart to find a cleaner piece inside.

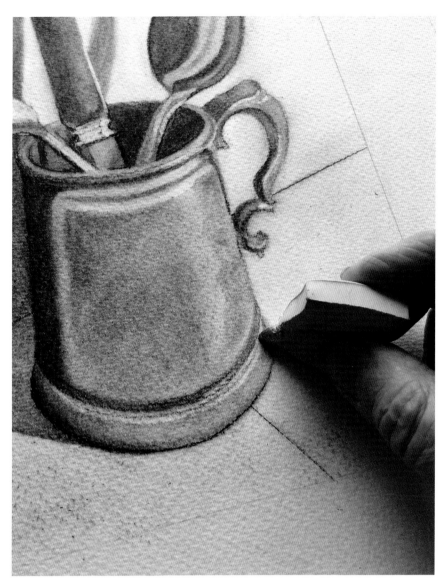

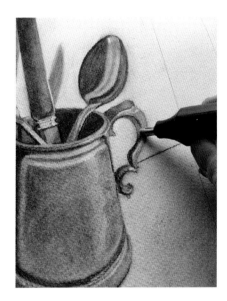

To create highlights in erased areas, try using a battery-operated eraser, which has a fine tip. Think of it as a drawing tool for drawing white marks.

STAGE 4

Lastly, look carefully at your still-life set-up to identify the lightest areas and the highlights. Use a putty rubber to lift the charcoal, creating areas that are lighter than the lightest mid-tones. The putty rubber is malleable, and you can squeeze it to create a pointed shape for erasing finer details. If you erase too much, creating a tone that is too light, use a paper stump to rub a little charcoal back into that area, until the right level of tone is achieved. If the tone is not light enough, you may not be able to remove enough charcoal with the putty rubber, so try using a battery-operated eraser instead (see inset).

As you create these lighter areas, look again at the overall composition, checking to see if the dark areas are dark enough and if you have missed any highlights. The finished drawing should have black areas, white areas, and a good range of tones in between. When you have completed the drawing, use the putty rubber to clean up any unwanted smudges from around the edges of the paper.

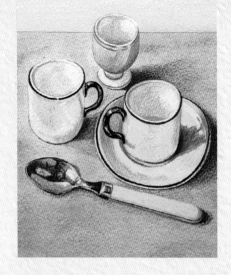

FOCUS ON

Observation

Making an accurate drawing of something requires you to look at the subject, gather some information about it, hold that information in your mind for a moment, then draw it.

The more you study an arrangement of objects, the more details you will observe: the contrasting shapes and colours, of course, the relationships between the objects, and the shadows and highlights. But you will also start to notice the reflections in the mirror-like bowl of the spoon and the more subtle reflection of one object in the surface of another.

When you are new to drawing, you will soon discover that there is a conflict between what you see and what you know. To develop an artist's eye, it is important to look at the subject as if you have never seen it before, so you do not make assumptions about how it's supposed to look.

Whether working from life or from a photograph, you should be able to glance from one to another without moving your head. The only things that should be moving are your eyes and your hand: glance at the subject, then at your paper, at the subject, then your paper. The time taken between looking and drawing should be as short as possible – and you should ideally spend more time looking at the subject than at your drawing.

Drawing shapes is easier than drawing things, especially if the thing has a name. So, while you look at your subject, try to identify shapes. Start by drawing large shapes, then the shapes within shapes. Try to draw the

relationships between the objects and not just the objects themselves.

Drawing is a process: you make some marks on a piece of paper and those marks act as a guide to where you should make the next marks. As you start drawing, some of the lines you make will be wrongly placed and you will want to make adjustments as the drawing begins to develop. It is best to leave the initial lines alone and draw the more accurate lines alongside or on top. This is called 'restating'.

Ellipses in still life

An ellipse is a circle seen in perspective. When you draw a still-life set-up that includes items such as bottles, cups, bowls, goblets and various other cylindrical objects, ellipses will be involved. When you look down at one of these items from an angle – three-quarter view – it is usually easy to discern the ellipse at the top but not so easy to see the one at the base. Many people, when they have little or no experience of observational drawing, see the ellipse at the top but, understanding that the base of the object, being flat, is sitting on a flat surface, will draw it flat – perhaps without realizing – because that's what their logical brain tells them to do (**1A**).

To help achieve an accurate shape, try to observe and draw both what is seen and what is unseen. In the case of a cup or a goblet, for example, draw not only the ellipse at the top, which you

1A **1B**

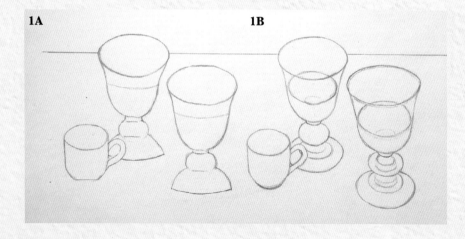

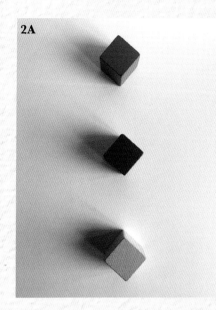

2A

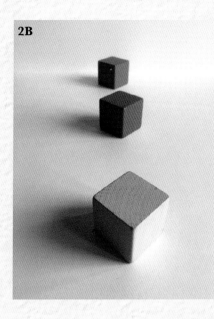

2B

it is important that you observe the relative differences. If you are having trouble convincing yourself how large or small each one should be, hold up a ruler and line up the edge with each object in turn, making a note of each measurement and the ratios between them.

Working from photographs

One of the great things about still life is that it stays still, giving you plenty of time to observe and draw. Sometimes, however, you may wish to take a photograph to work from at a later date. Working from a photo has its advantages and disadvantages. On the minus side, the colours are sometimes not quite true and you can't view the objects in three dimensions, to truly understand their form. On the plus side, the camera has done the job of flattening the subject into a two-dimensional format, so you don't have to rely so heavily on your observational powers; you could even take a tracing of the composition, if you wish, and transfer it straight to your painting surface.

Bear in mind, however, that the built-in camera on your mobile phone, with its wide-angle lens, might distort some of the objects (**3A**) and you may have to compensate for this (**3B**).

can see clearly, but also the one at the base, which you can see only partially. This will help you to understand how the flat base appears in reality when it sits firmly on the flat surface of the table (**1B**).

Perspective

Perspective is all about representing three-dimensional objects on a two-dimensional surface. If we achieve this, we give the viewer an accurate impression of height, width, depth, and the position of objects in relation to one other. When objects overlap, the spatial relationship can be easier to determine.

Linear perspective – something that you may already know a little about if you have done landscape drawing – means that the further away an object is, the smaller it will appear.

Test this out by selecting three objects that are the same shape and size – apples, lemons, cans of food, or wooden building blocks (as shown here), for example – and placing them on a table. From above (**2A**), you can see that these three wooden cubes are evenly spaced. Now lower your viewpoint (**2B**). You know that the

three objects are the same size and an equal distance apart, but the nearest one appears larger than the other two; the middle one is smaller than the one at the front but larger than the one at the back. This is logical, when you think about it, but you may be surprised to know that many people, when sketching an arrangement like this, will draw them all the same size. That is because they know they are the same size in actual fact, and they tend to draw what they know about the objects, not what they actually see.

Now try making a drawing. You can use this photograph (**2B**) or, better still, set up your own arrangement of three things. Your logical brain will tell you that they are all the same size, but

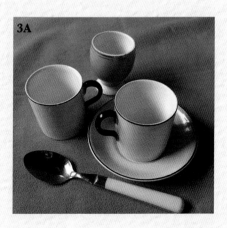

3A

3B

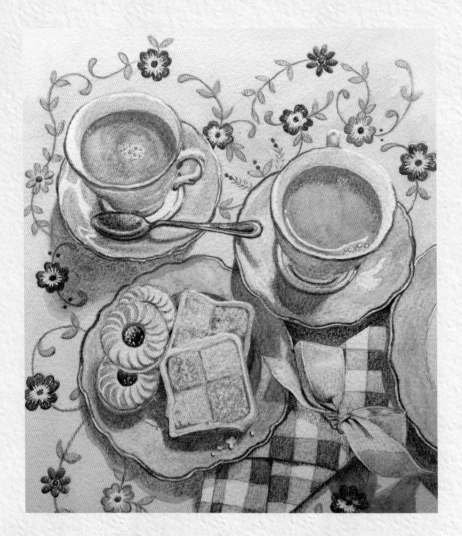

Tea and Cake
in Mixed Media

*Some subjects particularly lend themselves to a mixed media approach.
Here, a combination of watercolour pencils and coloured pencils is ideal for
depicting the smooth surfaces of china cups and saucers, and the crumbly texture
of cake. Lay the table with a pretty cloth and your best china, and resist
eating the sweet treats until you have finished drawing!*

YOU WILL NEED

graphite pencil: 2B • watercolour pencils: colours to match tea, cups, saucers,
plate and spoon • coloured pencils: colours to match cakes and fabrics
white gouache paint • tissue • eraser • round paintbrushes: sizes 6 and 2
cold-pressed watercolour paper (Bockingford) • drawing board
drawing pins, board clips or masking tape • easel (optional)

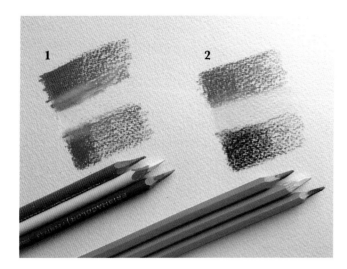

There is no mystery to the term 'mixed media'. It simply means combining two or more different materials in a picture: in this case, coloured pencils and watercolour pencils; white gouache is also added at the end, constituting a third medium.

You may think that coloured pencils and watercolour pencils are not so different from one another, but each has its own properties and attributes, advantages and disadvantages. With good-quality coloured pencils, the fact that they have a wax-based (or, in some cases, oil-based) binder, allows them to easily be applied on top of one another and blended. They can also be burnished to create rich, smooth areas of colour and tone, and can be used on a wide range of different paper surfaces and weights. However, if you wish to erase an area or to create lighter patches it can be difficult to remove the colour once it has been applied.

Watercolour pencils tend to have less intense colours when applied to the paper and, if you are going to add water, they work best on watercolour paper. The pigments are mixed with a water-soluble binder, not wax, making it more difficult to blend colours together when applying them to paper. By adding water, however, the binder dissolves, creating washes of pigment, allowing you to lighten areas of colour, and easily and quickly cover larger areas of paper.

So, as a general rule, on areas of the drawing where you want more textured marks and richer pigments, you can use non-soluble coloured pencils, which won't be affected by the addition of water but can be softened and blended in other ways, such as rubbing them with a paper stump or burnishing; while on areas where you want more subtle colour and the ability to move colours around and create washes, water-soluble pencils are very useful.

The wax-based pencils (1) can easily be blended by laying them on top of one another and applying a little pressure, while the water-soluble variety (2) do not blend so easily. When water is applied (above), however, the watercolour pigments can be blended more easily.

Setting up

Arrange your cups and other items on a table so that you are viewing them from a three-quarters angle (see page 25). Here, I have covered the table with an embroidered cloth, filled the cups with tea, arranged some biscuits and slices of cake on a small plate, and added a neatly folded checked napkin tied with a ribbon bow. The colours are pale pastels, with a predominance of pink and complementary green. The table is in front of a window, so there is natural light coming from behind and slightly above the arrangement.

Tape or clip your paper to a board; there is no need to stretch the paper because you will not be adding much water. Place the board on an easel, if you have one, or prop it up on a table or other surface.

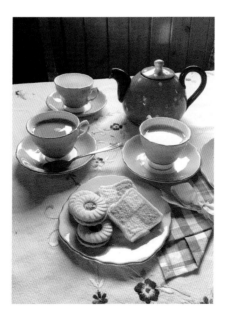

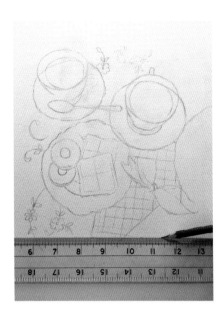

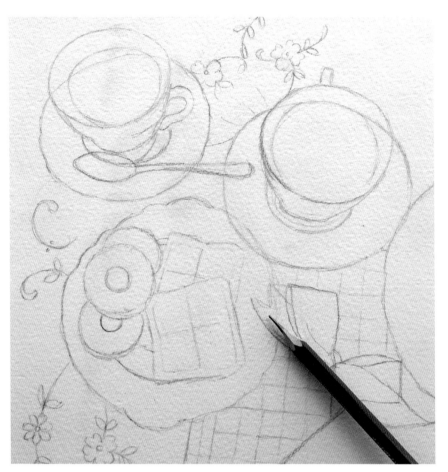

For an eye-catching picture, you need to be selective in deciding what to include and what to leave out.

STAGE 1

Use a 2B pencil to lightly sketch the foundation drawing. Draw the overall shapes of the cups and saucers and other items, overlapping lines if necessary, to get the shapes right. Look for negative shapes (see page 40), such as those between the edges of the saucers, to help you to draw the objects accurately. Look for relationships to help you to draw things in the correct position; for example, the top edge of the cup on the right is level with the top of the handle on the other cup. Observing where the lines on the napkin and the pattern of embroidered flowers on the cloth touch and intersect with the solid objects can also help with the composition.

Once you have decided on your composition, draw an enclosing box using a ruler and pencil. Bear in mind that you don't have to include every item on the table. I decided to leave out the teapot and the third cup, and to crop the composition through the rim of the larger plate. I then realised there were some large blank shapes – areas of plain tablecloth, without embroidery – so I added more flowers, to add visual interest and to balance the solid objects with decorative elements.

Tip

As with all still-life pictures, think carefully about the composition before committing yourself to paper. I have observed many inexperienced students drawing an arrangement of objects on a very small scale just so they could fit the whole tabletop into their drawing. If you were tempted to do this, think again: try zooming in and cropping (see page 24) to create emphasis and an interesting focal point.

Tip

When using watercolour pencils, test colours on a spare piece of paper and dampen them with a brush and clean water, to help you gauge how much to apply when colouring your drawing.

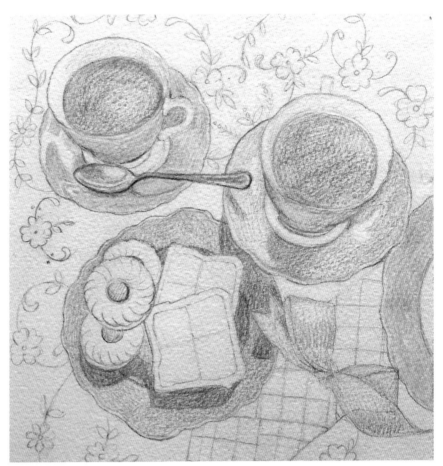

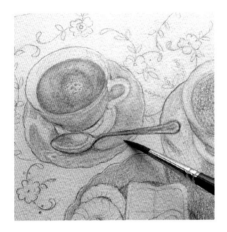

A good round brush will come to a fine point, allowing you to apply water in detailed areas as well as wider sweeps of colour. The brush shouldn't be too wet: dip it in clean water, then blot it on a paper tissue. And clean the brush in water before moving on to a different colour, or the colours will become mixed and muddied.

STAGE 2

Erase any unwanted pencil lines and lightly rub over some of the other lines to make them less dominant, especially where tones need to be kept very light, such as along the top rims of the teacups where they are seen against the pale tones of the tablecloth. Use water-soluble pencils for all the smooth surfaces, filling in the shapes with the appropriate colour. There were a few bubbles on the surface of the tea, so I drew these first, using a white pencil and enough pressure to cause indentations in the paper (incising). Then I shaded in the shapes made by the tea in each of the two cups, using the closest colour from my set of pencils.

When shading the various shapes in the composition, use light to medium pressure, and don't add too much colour to begin with. Once water is added, the colour will intensify, so it's better if it's a little too pale, as you can always add another layer; if it's too dark, it will be difficult to rectify. For the pale pink tablecloth, it was necessary to apply the pencil very lightly indeed. Once all the shapes have been filled in, wash over each one in turn, using a size 6 round brush and clean water (see inset). The water will dissolve the pigment and soften the pencil marks.

If at any stage you wish to add more wet colour, you can pick up pigment from the tip of a watercolour pencil, using a damp brush, and paint it straight onto the paper. This method is great for adding fine details.

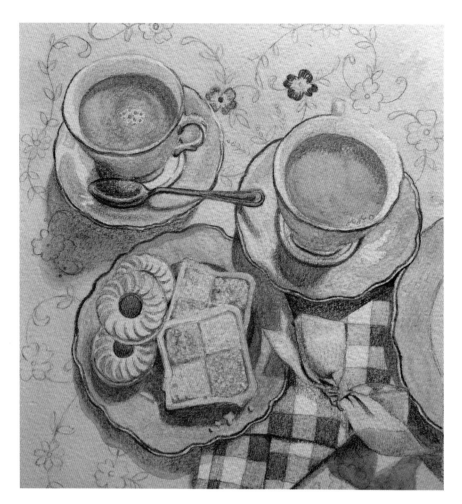

STAGE 3

Leave the painted areas to dry completely, then start filling in the other areas of the composition using standard coloured pencils. Cold-pressed paper tends to have a medium-rough surface, and this will help to create some texture. You can apply colour to the unworked areas of the picture and also work on top of the colour washes you created in stage 2.

If your set of pencils doesn't have an exact colour match for the area you are working on, blend two or more colours together, or use the nearest equivalent colour. Remember, this is your drawing and the colours don't need to match the original objects exactly.

For shadow areas, use a neutral grey that harmonizes with the other colours in the drawing. Bear in mind that where there is a shadow area on an object, such as one of the cups and saucers, it is not a darker shade of the local colour: the shadow on a pink cup is not a darker pink, it is a neutral. The best way to achieve a believable shadow colour when using coloured pencils is to colour this area in the local colour – in this case, pink – and then layer its complementary – green – over the top. If you need to make the shadow slightly darker, then layer a neutral grey on top of it. Build up the shadows gradually in this way, using light to medium pressure.

Good-quality colouring pencils are soft and wear down quickly, so make sure you sharpen them regularly while you work. A sandpaper block is ideal for sharpening the lead to a fine point for thin lines and details.

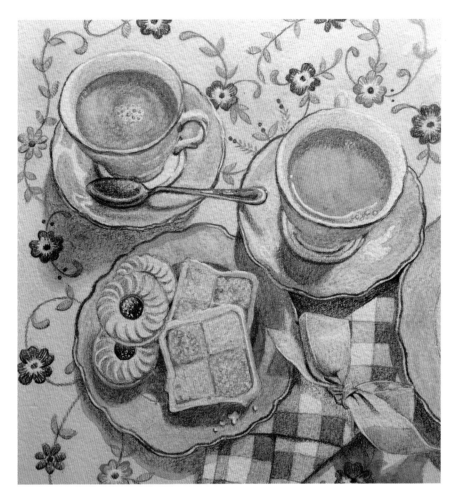

Use the very tip of the brush to apply tiny dots of white gouache to indicate grains of sugar on the biscuits.

Tip

Whether you are working in coloured pencils, watercolour or pen and ink, a tube of white gouache is a handy thing to have in your kit. Because it's opaque, it can be painted on top of other media, to create white highlights and even to cover up mistakes. Good alternatives to white gouache – and more convenient to use if you are out and about making drawings in your sketchbook – are white gel pens or paint pens (see page 12).

STAGE 4

Keep working on the various components of the composition until you are happy with the overall effect. Now you can add another medium: white gouache. Squeeze a small blob of the paint onto your palette and add a little water. Do not dilute it too much: it should have a creamy consistency that flows well, but it should not be too thin, otherwise it will not be opaque enough. Dip the tip of the size 2 brush into the paint and test it on a scrap of paper, twirling it to refine the point of the bristles. Apply this white paint to create highlights and sheen. Look carefully at the objects in front of you and see where, for example, the light catches the surface of the liquid in the cups, the rims of each of the items of china, the indented lines on the handle of the teaspoon, and the edges and creases on the ribbon. Finally, add dots to the biscuits to indicate a sugary topping.

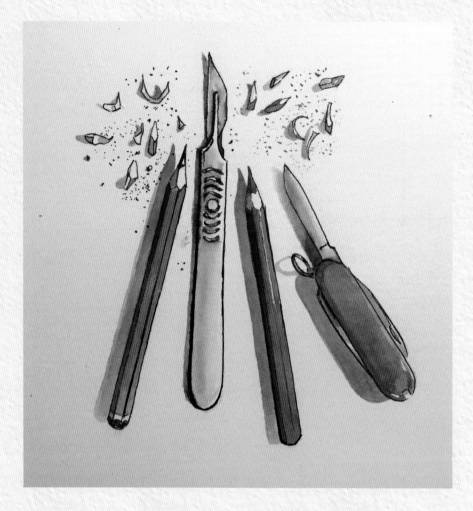

Art Supplies
in Line and Wash

As we have already seen, you don't have to explore far afield to find subjects for your still life – and here, I suggest you look no further than your art kit. Drawing tools are the subject for this mixed media picture. While using simple lines to describe shapes and details, you'll discover the differences between water-soluble and waterproof inks when adding touches of tone and colour – and learn a little about watercolour, too.

YOU WILL NEED

graphite pencil: HB • fine permanent pen • soluble-ink pen
watercolour paints: ultramarine, burnt sienna and cadmium red
plastic eraser • small plate or palette • round paintbrush: size 4
140lb (300gsm) hot-pressed smooth watercolour paper
drawing board • drawing pins, board clips or masking tape

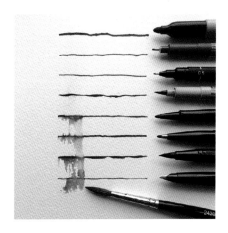

Tip
A size 4 round brush is a good size for this drawing as it holds a reasonable amount of water. Make sure you choose a brush that has bristles that form a fine point when wet.

Here you can see that the four pens at the top are waterproof and the four below contain water-soluble ink.

For this mixed media drawing, you will need a pen with soluble ink and one with permanent ink. Permanent or waterproof pens are usually labelled as such, while water-based pens are less likely to be labelled. If you are not sure what you've got, you can perform this simple test (see above): gather together a collection of whatever black pens you have in your box of materials – felt pens, markers, perhaps a brush pen or a fountain pen – and, using each one in turn, draw a line on a piece of paper. Leave it for a minute or two, to make sure that the ink is dry. Then take a brush, dip it into clean water and stroke it across all the lines. Those that are made with permanent ink will not be affected, but those that are soluble will visibly smudge or run.

To be able to place tones where they are required in this drawing, you will need to be able to control the paintbrush. You will also need to be able to control the amount of water used, in order to produce light, medium and dark tones. If you are not confident, it's best to practise first on a spare scrap of paper and keep a paper tissue handy, to blot off any excess water from the brush.

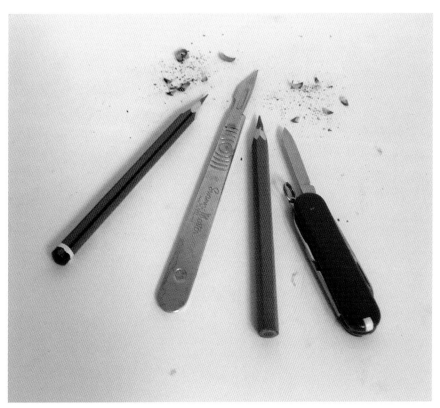

Setting up

You will need two pencils for this set-up. Choose red pencils if you have them; if not, two yellow pencils or two blue ones. This drawing will be made with black pens, one neutral shade of paint, and one colour. You will also need two knives. The ones shown in the picture are a scalpel and a penknife, both of which are excellent tools for sharpening pencils to a fine point.

Place a sheet of white paper or card on a flat surface with the light coming from one side – in this case, from the right. Use the knives to sharpen your pencils, allowing the pencil shavings to fall onto the paper. Then place the knives and pencils in position on the paper. Check that the light creates a bit of shadow on one side of each of the objects, including the tiny shards of pencil shavings.

Pin or tape your hot-pressed watercolour paper to a board and position yourself so you are looking down on the arrangement. Now you're ready to get started on the drawing.

STAGE 1

Lightly draw the outlines of the objects onto your paper. You don't have to use pencil – you can go straight in with a pen if you prefer – but you may feel more confident if you use a pencil first and you can erase any markings you don't like. You can use a ruler to obtain the straight lines, if you wish, but it may end up looking too technical. Practising drawing straight lines freehand is a little exercise you can do in your sketchbook and it can help you to become more confident. To help you get the proportions right, look for any points of reference and observe the negative spaces (see page 40).

STAGE 2

When you are happy with the arrangement, use the pen with soluble ink to draw the outline of the scalpel, including the blade, and the blade of the penknife. These parts of the drawing will not have any colour added, just washes of grey produced by brushing with clean water.

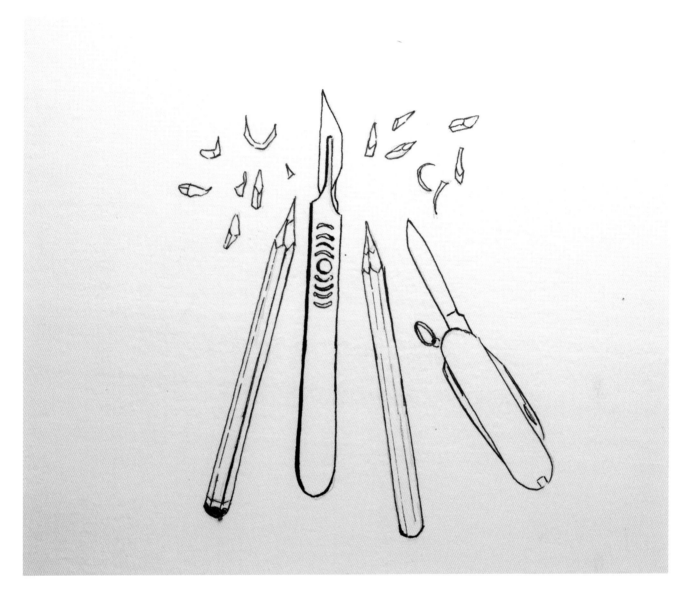

STAGE 3

Complete the outline drawing, but this time use a permanent pen. If possible, choose one that produces a nice fine, even line. When you are happy with the drawing, wait a few minutes to make sure the ink lines are dry, then use a plastic eraser to rub out all the pencil marks.

A plastic eraser is useful for removing pencil marks – but make absolutely sure the ink is dry before you do this, or it will smudge.

Tip

You will see that, when you apply water to soluble ink, the lines you have drawn will become a little fuzzy. This is the nature of this type of line and wash technique and, once you have tried it for yourself, you can decide when and how to use soluble inks in your drawings.

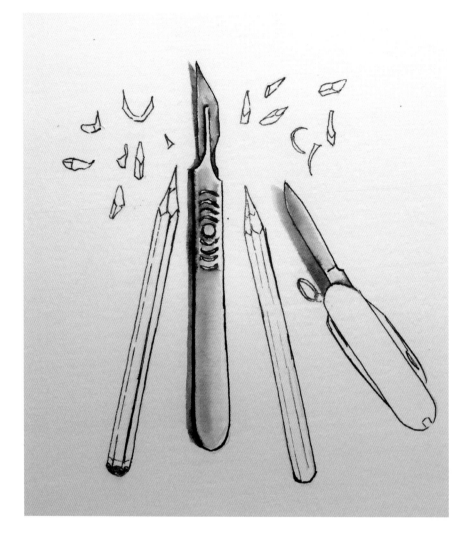

When applying water to the lines made with soluble ink, your brush should be damp, rather than dripping wet.

STAGE 4

Once you are happy with your line drawing, you can begin to create a tonal wash. Dip your paintbrush in clean water and stroke it down the side of the scalpel, to partly dissolve the ink line and create a narrow band of shadow. Do the same with the blade of the scalpel and with the blade of the penknife (see inset). Look at the objects you are drawing, to identify where these tonal areas should be placed, and try not to paint over any areas where there are lighter areas, or highlights.

Take your time with this, especially if you are new to pen and wash drawing. Marks made with water-soluble ink will remain soluble, even after they have dried, so there is no rush. And try not to add too much water: you will have more control if you are using a damp brush rather than one loaded with too much water.

Test out a number of different dilutions on a scrap of paper before painting in the areas of tone on your drawing.

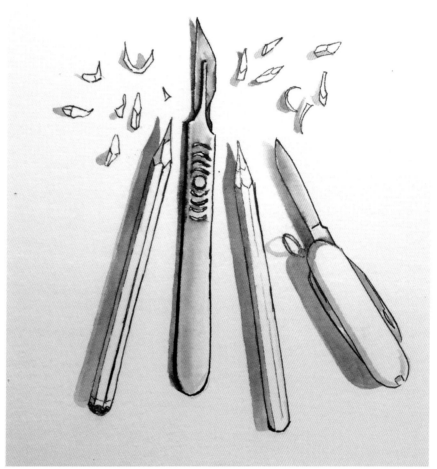

Because you are painting shapes that have been outlined with permanent, waterproof ink, the paint will remain red; if you were to paint shapes that had been drawn with soluble ink, the black ink would run into the red.

STAGE 5

For the areas of the drawing where you have used permanent ink, you will have to use diluted paint in place of just water to produce areas of tone. Squeeze out a small blob of ultramarine and one of burnt sienna. Mix these to make a neutral shade. The more water you add, the paler the tone (see inset). Look for cast shadows. These are easy to see with the pencils and knives, but if you look carefully at the pencil shavings, you'll see that each has its own tiny shadow. Once again, avoid adding paint to areas where there are highlights. Finally, once you are happy with the grey-painted areas, mix up a little red paint with water (see inset), and use this to paint the pencils, the shavings and the penknife handle.

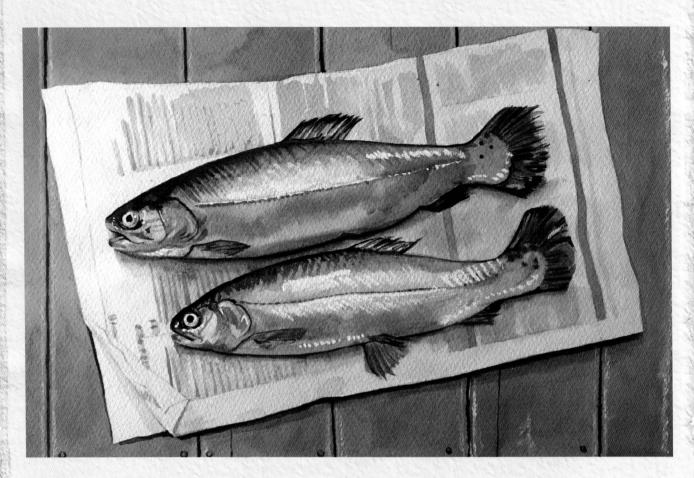

Fresh Fish in Watercolour

Two freshly caught rainbow trout are the subject of this tutorial. They are painted in watercolour using a limited palette of just four colours. Fresh fish are a great subject for painting because you have to work quickly, before they begin to go off, which is a good way to prevent you from overthinking.

YOU WILL NEED

graphite pencil: 2B • watercolour paints: lemon yellow, permanent rose, burnt sienna, ultramarine • white gouache paint • sponge eraser • round paintbrushes: sizes 12, 6 and 2 • cold-pressed 140lb (300gsm) 100% cotton watercolour paper • drawing board gummed brown-paper tape • easel (optional)

When using lots of watercolour, as you will be here, paper that is 140lb or less tends to buckle and this leads to the paint collecting in pools. It is therefore advisable to stretch watercolour paper on a board, which will help to prevent this from happening and ensure that, when it is dry, your drawing or painting will be completely flat.

1. You will need a drawing board, a piece of watercolour paper smaller than the board, gummed brown-paper tape, 2in (5mm) wide, a sponge, and water.

2. Immerse the sheet of paper in cold water, in a tray, a sink or bath. Meanwhile, cut four lengths of gummed tape, each a little longer than the sides of the paper. When the paper is thoroughly wet, lift it out, gently shake off any excess water, and place it on the board. Smooth it out, using the sponge, taking care not to rub the surface of the paper.

3. Moisten the gummed paper strips, one by one, and place them along the edges of the paper, to attach the paper to the board. The strips should overlap the paper by at least ¾in (2cm). Leave to dry, with the board flat and away from direct heat.

Tip

Stretching paper should result in a nice flat piece of paper held down on all sides by tape. Sometimes, however, the tape lifts and the paper becomes cockled. If this happens, remove the paper from the board, re-soak it and repeat the process. Any fragments of the original brown tape that are still attached to the paper can easily be removed during or after soaking. To ensure success, make sure the paper is completely flat on the board before applying the tape, and also make sure that the tape is evenly moistened, with no dry patches, but not so wet that the gum is washed off. Make sure, too, that the board remains horizontal while the paper is allowed to dry.

Setting up

Stretch the paper on a board using gummed paper tape (see above) and place it on an easel, if you have one, or propped up on a table or other surface. Place one or two sheets of newspaper on a plate and arrange the fish on the paper. Place the plate on a surface so that you can look down on it – in this case, I have used a painted wooden chair, which not only places the subject at a convenient height, but also adds a touch of bright colour to the arrangement.

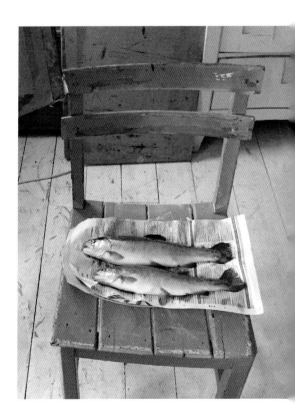

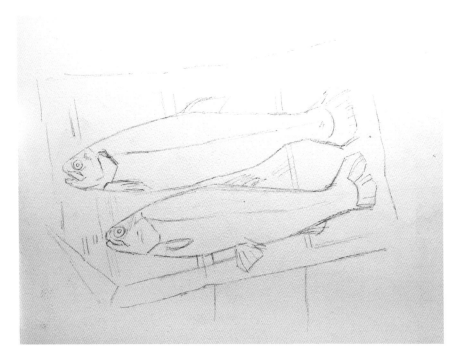

STAGE 1

Use a 2B pencil to lightly sketch out the foundation drawing. Draw the overall shape of the newspaper. Use the lines and blocks of text on the newspaper to help with the positioning of the various parts of the two fish, looking carefully at what points these various components overlap and intersect. Don't just outline the fish but look for helpful shapes: see how they are broken down into head, tail and fins, and how the body is divided in two by a line running down the centre.

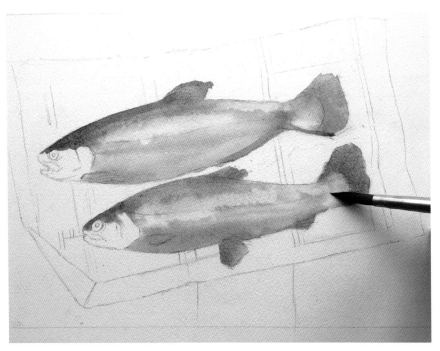

STAGE 2

Using a size 12 brush and clean water, wet the fish shapes, apart from the eyes and lower part of each head. Stroke on washes of colour. Three washes are used here: a grey, mixed from burnt sienna and ultramarine; a bluish pink made from permanent rose with a tiny touch of ultramarine; and a blue, which is ultramarine with a tiny touch of burnt sienna (see swatches, page 13). All three colour mixes are diluted with plenty of water. Once they have been applied, swirl the brush in a pot of water to wash off the paint, dip it into clean water, shake or blot off any excess water, and use the damp brush to lift off paint to reveal the white paper in areas you consider to be too dark at this stage. Do this quickly, as it is easy to lift off paint while it is still wet. And be sure to rinse the brush frequently in clean water.

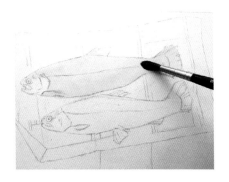

By wetting an area of the painting before applying paint, the colours will merge and blend together where they meet, creating a soft effect. The paint will not run outside the wet area.

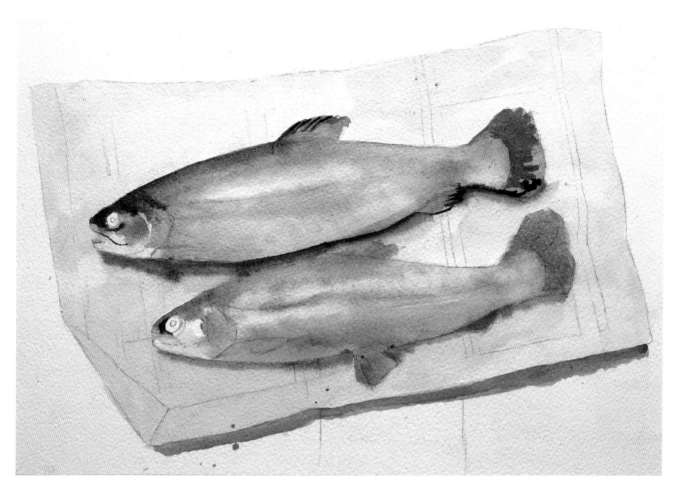

Tip

You may think a size 12 brush is too big and clumsy for a painting like this. However, there are advantages to using a large brush, as the 'belly' of the brush is capable of holding a larger quantity of water or paint than a smaller brush, meaning you don't have to reload it so often. Also, as long as it is a good-quality brush, the hairs will taper to a fine point, allowing you to paint fine details as well as broad strokes.

STAGE 3

Leave to dry, then use the size 12 brush and more clean water to wet both fish, apart from the eyes. Apply more washes, this time adding a dilute red made from permanent rose with a touch of lemon yellow; a greenish shade made from lemon yellow and ultramarine; a little burnt sienna to the lower fin; and any other colours you can see. Refer again to the colour swatches on page 13. Once more, because you have wetted the paper, the edges of the colours will merge together.

Allow the paint to dry, then paint the whole area of newspaper that surrounds the fish, using a watery grey. Then, while the wash is still wet, add darker grey shadows under the bellies of both fish. You can also use this colour to start to add details to areas such as the fins and the eye sockets; because the paint on the fish is now dry, these marks will be more defined, with harder edges.

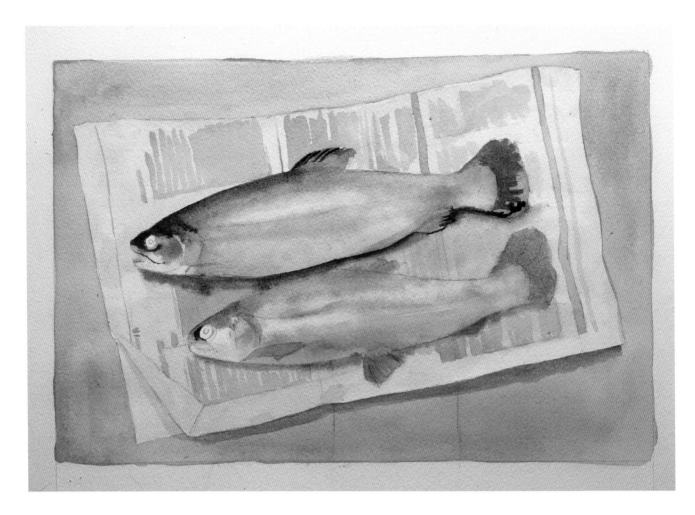

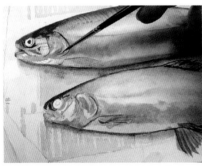

Use a dark mix of the neutral grey shade, mixed from burnt sienna and ultramarine, for the very dark areas, such as the centres of the eyes.

STAGE 4

Now paint the background. In this case, it is the orange colour of the painted chair, mixed from permanent rose and lemon yellow. Paint an overall wash in one shade of this colour. If it dries too pale, you can always add a second coat later.

The grey wash on the newspaper should be dry by now and you can use the same grey wash you used for this to paint in the blocks of text. Because watercolour is transparent, this second application of the same colour will be darker, as you are creating a double layer in these areas. This newspaper also has a couple of blue lines across it. I mixed a little ultramarine into the grey for these lines. The text on the newspaper is painted as pale blocks of grey, to give the impression of printed paper without distracting from the fish.

While this is drying, start working on some details of the fish. For larger areas, the size 12 brush can be used; for smaller shapes, such as the fins and the coloured shapes on the face, use the size 6; when it comes to finer details, swap to a size 2.

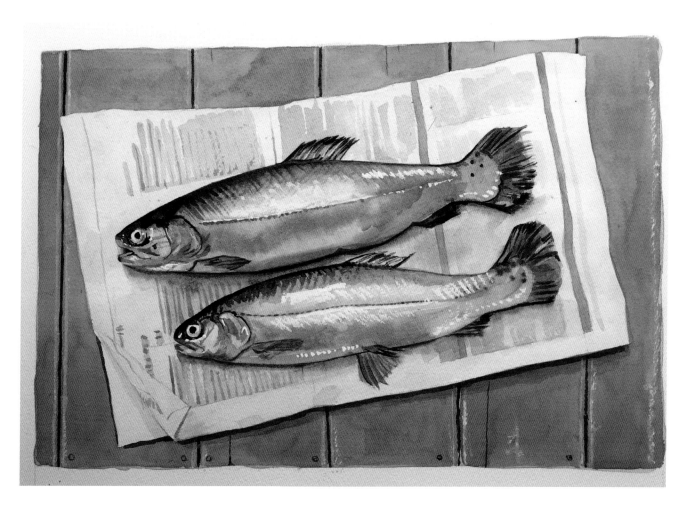

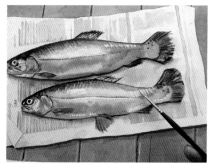

Squeeze a small blob of white gouache onto your palette and add a little water. Do not dilute it too much. Dip the size 2 brush into the paint. Test it on a scrap of paper first: you don't want too much paint on the brush. Use it to add highlights.

STAGE 5

Continue adding more details to both the fish and the newspaper. Use the size 6 brush to add a third layer of the grey wash you used earlier on the newspaper, to suggest the lines of text. Use the dark neutral grey shade, mixed from burnt sienna and ultramarine, for the darkest areas of the fish, and to strengthen the shadows directly under the bellies of both fish. You can also use this mix to delineate the cracks and crevices on the chair seat. Use the size 2 brush to apply white gouache on the fish, to create accents and highlights. Finally, for distressed areas of the wooden chair seat, mix a little of the orange paint with the white gouache. Make sure the mixture is fairly dry, with not too much water added, so that when you apply the paint, it creates a slightly rough, broken texture.

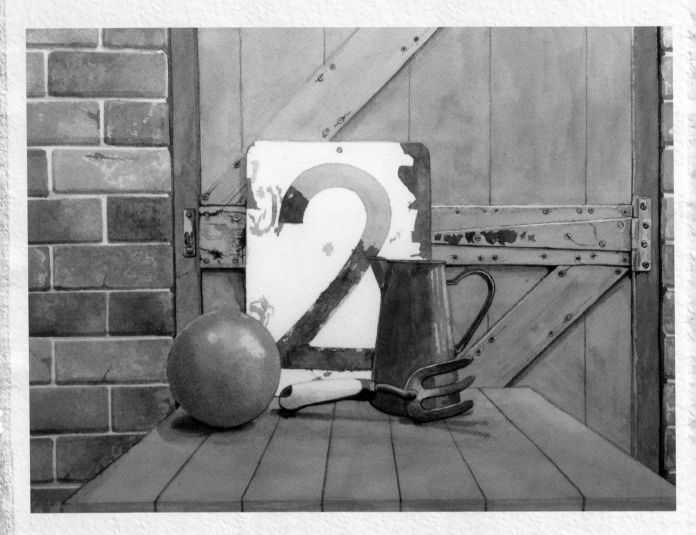

Garden Objects in Watercolour

For this project, we will go outside in search of still-life objects, set them up against an interesting backdrop, and make a painting in watercolour. You can use the same basic set of four colours that you used in the Fresh Fish tutorial on page 74 or add a couple of extra shades to your palette.

YOU WILL NEED

graphite pencil: HB or B • watercolour paints: lemon yellow, burnt sienna, permanent rose, cerulean blue, French ultramarine, cobalt blue
white gouache • sponge • eraser • round paintbrushes: sizes 12, 6 and 4
small piece of cardboard • small offcut of wood • all-purpose glue
cold-pressed 140lb (300gsm) 100% cotton watercolour paper
gummed brown-paper tape • drawing board

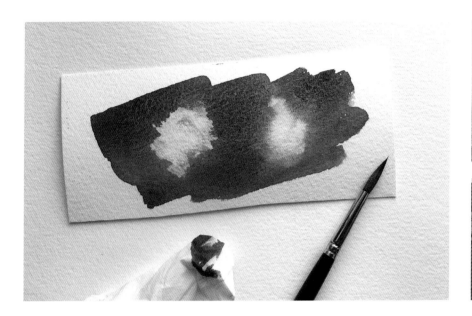

This painting is done on a reasonably big scale, which involves some large areas of solid colour. The colour is applied as a 'wash'.

You need to apply washes quite quickly, to ensure that there are no unsightly 'joins' where one area of paint has had time to dry before applying the next. So, use a nice big brush that will hold a lot of paint so that you don't have to keep returning to the palette to reload it. It also helps to mix up plenty of paint in the first place.

If the wash is too pale, never mind: just carry on applying it over the whole area and leave it to dry, then you can apply a second wash – another layer – on top, which will darken it. As long as the first layer is dry, the second application will not disturb it.

Brush some watercolour onto a spare scrap of paper and try lifting out some of the wet paint using a tissue, then using a clean, damp brush, to see which method suits you best.

As soon as a wash has been applied, you have the opportunity, while the paint is still wet, to remove paint from an area where there is a lighter tone, such as a highlight or reflection, by dabbing it with a paper tissue or using a damp brush. This process is called 'lifting out'. If you do this after the first wash, lifting out will reveal the white paper beneath; if you do it after a second or subsequent wash, lifting out will reveal the colour immediately beneath.

Setting up

Look around your outdoor space, if you have one, for some items of interest. I collected together an old rusty sign, a glazed ceramic ball, an enamel jug and a hand fork. On page 49 I suggested making some painted wooden boards to use as props and backdrops for still-life arrangements, and I used one here, painted blue, as a tabletop, while the old back gate with its painted planks and rusty hinges makes the perfect backdrop. To introduce some complementary colour, I decided not to paint the wall on either side of the gate as it is but to transform it into a brick wall – which is what actually lies beneath the peeling paint.

So here are my suggestions for making your own outdoor set-up: place a table or box in a suitable location, find some interesting objects – taking into consideration not only their shapes, sizes and surface textures but colours too – and place them in a pleasing arrangement, then sit or stand so that they are straight on and at eye level or just below. Stretch the paper on your drawing board, using gummed tape (see page 75). You can then start drawing.

Tip
You may wish to make some thumbnail sketches (see pages 24–25) before deciding on your final composition and viewpoint. Even after I had begun my foundation drawing, I decided to remove the small bucket that was in my original arrangement and turn the hand fork around so that it was facing in the opposite direction. I could have saved myself some time if I had taken my own advice and done some thumbnails first!

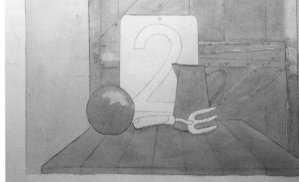

STAGE 1

Use an HB or B pencil to lightly sketch the foundation drawing. Draw the overall shapes of the objects, including the tabletop and the gate – or whatever surroundings you have in your own set-up. To get the shapes right, remember to look at the negative spaces (see page 40). Because of the low viewpoint, the top rim of the jug appears fairly level, while the base is slightly elliptical.

To enclose the picture area, draw lines using a ruler and pencil. The format I have drawn is landscape (horizontal) and measures 16 x 11½in (approximately 40 x 30cm).

There is no need to draw in any shadows or tone at this stage.

STAGE 2

Mix up washes in the main colours and test these on a spare piece of paper. Have an eraser handy, too, because as you begin to paint you may wish to lighten or erase some of the pencil lines of your foundation drawing. Once you are happy with the washes, apply them to the large areas and shapes in the composition, using the size 12 brush. This size of brush allows you to cover large areas of paper before the paint has time to dry, giving a smooth, unblemished result – and, if it's a good brush, it will have a fine tip that also allows you to paint into corners.

Here, a wash of lemon yellow with the tiniest bit of blue and burnt sienna to dull it down a little is applied to the wall on either side of the gate. A cobalt blue wash covers the gate itself. Cobalt blue has also been used to fill in the ball shape: you will see that the ball has a lighter area, where the damp paint has been lifted out (see inset). Next, the tabletop is covered with a cerulean blue wash and the jug with French ultramarine.

It is not easy to discern the difference between the three blues at this stage, when the colours are diluted with a lot of water, but they will look different once subsequent washes have been laid on top at a later stage. Of course, your set-up will be different, and you may choose to use only one shade of blue for your initial washes – or none at all.

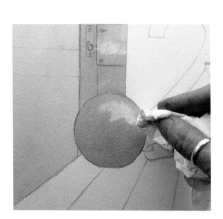

As soon as a wash has been applied, you have the opportunity to remove the paint from an area where there is a lighter tone, such as a highlight or reflection, by dabbing it with a paper tissue. This process is called 'lifting off'.

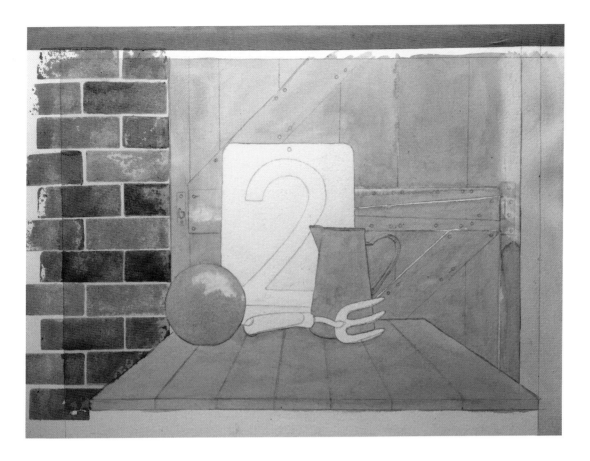

STAGE 3

Having decided to create a brick wall, I devised a shortcut for doing this. I worked out the shape, size and positioning of the bricks in my picture by looking at a nearby wall and measuring the bricks. I cut a rectangle of thick card and glued it to a small offcut of wood to make a stamp. I then mixed up several puddles of watercolour paint on my palette, using lemon yellow mixed with burnt sienna and adding a little ultramarine to some, to create a variety of colours, once again by observing a nearby brick wall to understand the various colours needed.

I dipped the stamp into one of the paint puddles and tested it by pressing it onto a spare piece of watercolour paper. If you decide to try this technique for yourself, you will discover that the cardboard stamp, being quite absorbent, will produce quite a patchy result at first and will need to be tested a few times before applying it to your painting. Of course, bricks have a texture, so it doesn't matter if the imprint made on the paper isn't a solid colour.

Before stamping the bricks, mask off the edge of the door and the tabletop with a piece of paper (see inset). Then stamp the

brick pattern, dipping the stamp into fresh paint after each application, and varying the colours for a realistic effect.

While you are waiting for the bricks to dry, paint the base colours of any other areas, such as the handle of the fork and the sign – in this case, both painted in a wash of lemon yellow.

A home-made stamp, like the one used here for the brickwork, makes quick work of a repeated shape. Mask off any areas you don't wish to paint.

The neutral mix, made from cobalt blue and burnt sienna, is useful for cast shadows as well as shaded areas of the objects. Here, it is applied with a number 6 brush. You will see that the ball has a mottled appearance. This is because cobalt blue is a granulating colour, which means that, as the paint dries, particles of pigment separate and fall into the dips on the paper. A large percentage of water in a wash helps to increase granulation, so this effect may be more apparent after a second wash is applied.

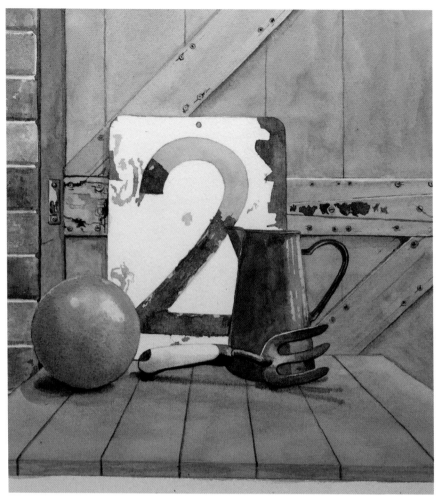

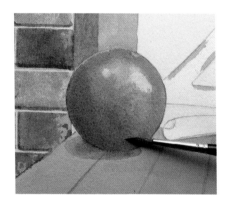

STAGE 4

Now you can apply more washes on top of the basic ones that were done in stage 2, which should be completely dry. Using a size 12 brush and clean water, wet the shape where you wish to add another layer of wash. For example, on the ball, another layer of cobalt blue has been applied, then some of it blotted off with a tissue to retain highlights. The highlights are smaller this time: where the wash goes over the previous areas of cobalt blue, it is now a deeper tone but where it goes over the lifted area, it is paler, and in the small areas where it has been lifted off for a second time, it is paler still.

This applies to the jug, too, where another layer of ultramarine has been applied and lines of paint have been lifted off, not with a tissue but with a clean brush and clean water. To do this, make sure the paint you have applied is still wet and that the brush is just damp. Carefully stroke the brush on the wet paint to lift it, rinsing and blotting the bristles of the brush frequently. Do this quickly, as it is easy to lift off paint while it is still wet but not once it has dried (see page 81).

You can also add shadows at this stage. This is easiest to see on the base of the ball, where a neutral grey colour, mixed from burnt sienna and cobalt blue, has been applied while the paint on the ball is still damp, creating soft edges where the grey and blue colours merge. You can use this same neutral mix, or a similar mix of burnt sienna and ultramarine, to add shadows elsewhere in the picture, including the lower edge of each brick. Look carefully at your still-life set-up, to see where the shadows fall. Use more water where these areas are light in colour, and less water for a deeper colour. To paint lines between the planks of the door, use the size 4 brush.

For rusty areas, you may wish to add more burnt sienna to the neutral mix, and even some yellow, to make a rusty brown colour.

Tip
This still life is quite formal, with the objects on the table forming a triangle or pyramid shape, and the side edges of the tabletop, seen in perspective, forming two diagonals, leading the viewer's eye into the centre of the picture and echoing the diagonal struts on the gate.

Some details in your picture will be really dark. Do not be tempted to use black paint as this can look heavy and unnatural. Instead, use a neutral mix of blue and burnt sienna with just enough water to make a fluid consistency.

STAGE 5

Keep building up colour in layers, until you are happy with the overall balance of the picture. Look carefully at your set-up to see if there are any small highlights that have been missed or overpainted and add these using white gouache mixed with clean water and a number 4 brush. You may also wish to use this brush with a little of the neutral mix – made with very little water so that it is almost black – to touch up any really dark areas of the picture (see inset).

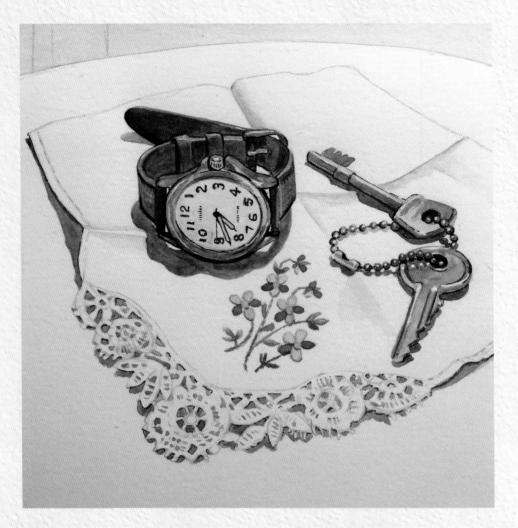

Watch and Keys in Mixed Media

The small items we use every day, often carried in our pockets or purses, can provide a rich source of subject matter for still-life drawing. In this mixed media tutorial, pencil is used for the foundation drawing, with watercolour added to depict the colours, light and shadows, then pen and ink used afterwards, on top of the paint, for a few crisp details.

YOU WILL NEED

graphite pencil: HB • watercolours: ultramarine, burnt sienna, yellow ochre, permanent rose, lemon yellow • dip pen with fine nib • Indian ink • masking fluid white gouache (optional) • plastic eraser • round paintbrushes: sizes 6 and 2 hot-pressed smooth watercolour paper • drawing board • drawing pins, board clips or masking tape • easel (optional)

Tip

Hot-pressed watercolour paper has a smooth surface that is ideal for light applications of watercolour; the surface also allows a metal pen nib to glide easily without encountering any awkward bumps or rough texture that might cause broken lines or spatters. Test your nibs on an offcut of paper.

For this still life you will need to find a pen nib to suit your drawing style. Some nibs are designed for drawing and some for writing, but for many people a writing nib makes the ideal drawing tool. The best way to discover which nib works for you is to try out a range on a spare piece of paper. Dip the nib about halfway into the ink, then tap the nib gently on the neck of the bottle to ensure there are no large blobs of ink. Make a variety of marks on the paper, varying the direction and pressure to make thick and thin lines.

Setting up

For this small-scale still life, collect a few items together and arrange them on a surface such as a chair seat or bedside table. Choose items that belong together and that are rich in detail. Play with the arrangement until you are pleased with the composition.

Here, a wristwatch with a leather strap and a pair of keys on a chain have been placed on a lace-edged handkerchief. The lace provides a good subject for identifying negative spaces

(see page 40). You could use different objects, of course; just think about their scale, colour, and the amount of detail they offer to add interest to the composition. Also think about lighting: this arrangement has enough natural light to create clear shadows and to clearly show the detail of the lace.

Attach the hot-pressed watercolour paper to your drawing board using drawing pins, board clips or small pieces of masking tape, and sit with the board propped up or placed on an easel, positioning yourself so that you have a three-quarter view of the set-up. Aim to position yourself so that, if you take a step back from your work, you can see your drawing and your subject at the same time, allowing you to make comparisons as you progress.

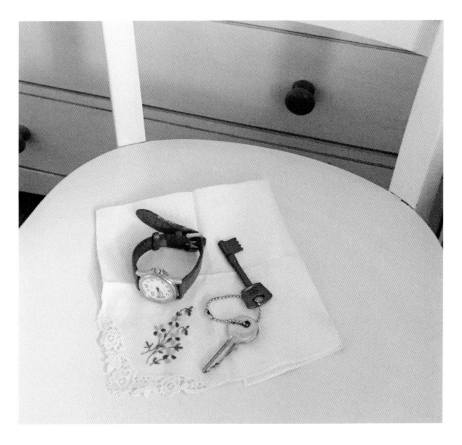

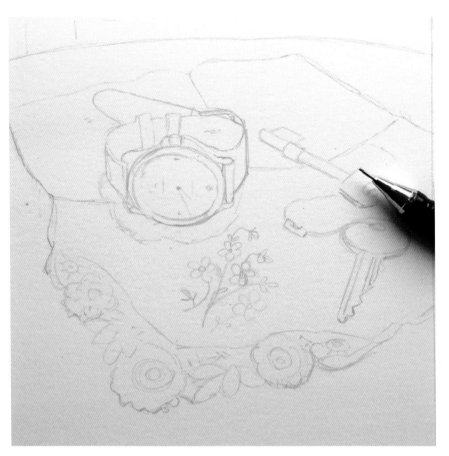

A dip pen with a fine nib is ideal for applying masking fluid. The fine tip allows you to apply tiny lines and dots and, once you have finished, it is easy to clean the masking fluid from the nib.

STAGE 1

Make a detailed pencil drawing of the subject, using an HB pencil. A mechanical pencil with a fine 5mm lead is ideal for a small-scale drawing like this: it produces a crisp line, which can be erased easily provided you don't use too much pressure, and if it breaks, you don't have to waste any time sharpening it. Include as much detail as you can – the drawing will be an important part of the finished piece, as you will not be adding a lot of paint. I have included the back edge of the chair seat, just to provide some context.

In preparation for stage 2, use the dip pen to apply masking fluid (see inset) to any areas where you wish to preserve the white of the paper. This doesn't include broad areas, such as the cotton fabric of the hanky or the seat of the chair, but small details that you don't want the paint to obscure – shiny highlights on the watch and keys, and small pinpoints of highlight on each of the links of the keychain.

Tip
To mask out really fine details, instead of using a pen (as I've done here), you can purchase bottles of masking fluid that have a built-in applicator, which you may find easier to use.

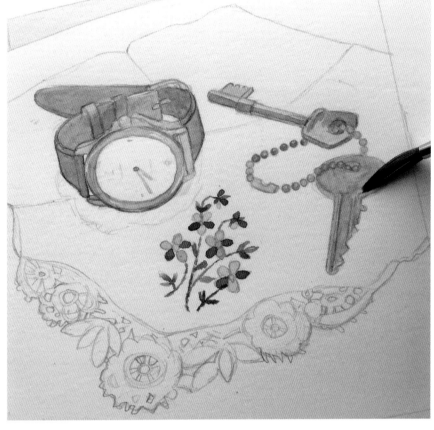

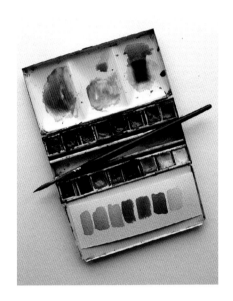

A supply of small pieces of watercolour paper is invaluable. Each time you trim a larger picture, keep the paper trimmings to use as test swatches for your colour mixes. It is easier to judge paint colours as brush strokes on paper than as puddles on your palette.

STAGE 2

Once the masking fluid is completely dry, it's time to start painting. A line and wash drawing can be a little like painting by numbers. Start by blocking in broad areas of colour using the size 6 brush: fill in the area behind the back edge of the chair seat, the shapes of the watch bevel and strap, the two keys and the chain that links them, and, in this case, the shapes of the embroidered flowers and leaves on the hanky.

For the background, a neutral mix of ultramarine and burnt sienna, well diluted with water, is an ideal shadowy colour that can also be used for the metal parts on the watch and the silvery key; it will also come in useful later when you add shadows.

For the brass key, I added a little yellow ochre to this mix to create a dull, brassy gold. For the watch strap, I mixed permanent rose with burnt sienna, adding a tiny touch of ultramarine to create the right shade of brown. For the flowers and leaves, I mixed permanent rose with ultramarine in various proportions to make shades of violet, and ultramarine with lemon yellow to make green. The flower centres and the watch hands were painted in lemon yellow.

Use your colour wheel as a reference (see pages 20–21) and test mixes on a scrap of watercolour paper (see inset) before applying it to your drawing. At this stage, you are creating an underpainting of sorts, so dilute your colour mixes with plenty of water; you can always add another layer of colour once these first washes are dry.

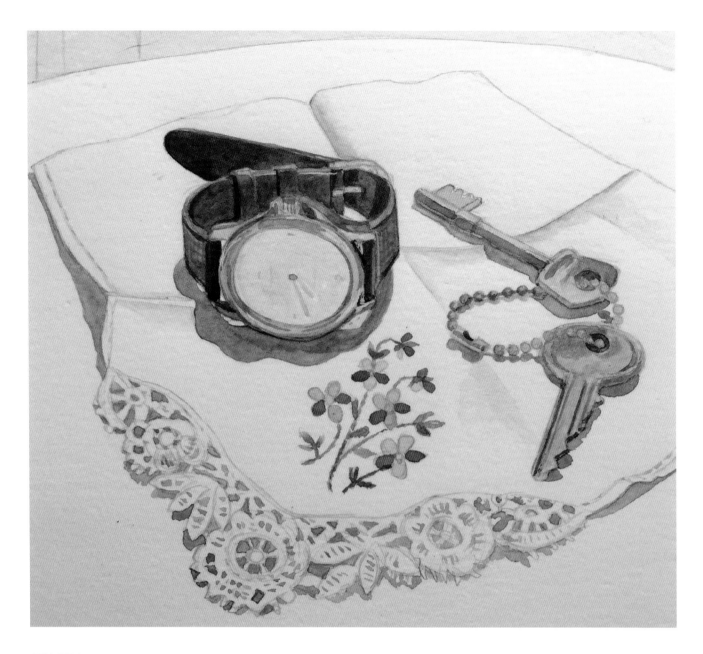

STAGE 3

Once the first washes of paint are dry, you can build up the colours with further layers of paint. Use your neutral colour mix to paint cast shadows on the handkerchief and darker areas of tone on the various items.

Use the size 2 brush and this neutral mix for the holes in the lace. You will need to carefully observe the shapes and the way they cast shadows on the surface beneath – but you don't have to be totally precise about each separate little shape. If you are not sure how to proceed with such a detailed item, before you commit yourself to the painting, practise on a spare piece of paper until you are pleased with the effect.

Once this stage is finished and you are happy with the progress so far, leave the paint to dry completely, then rub away the masking fluid using your fingertips.

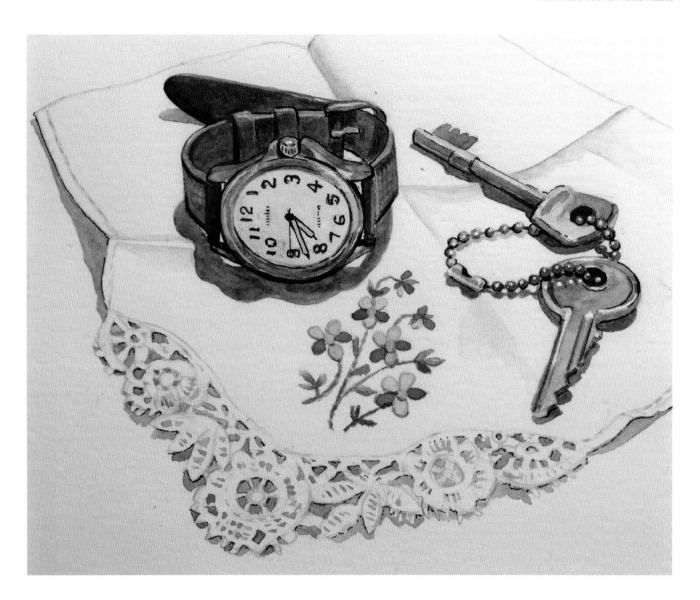

STAGE 4

With the same pen you used to apply the masking fluid, add details to your drawing using Indian ink (see inset). The idea is to use the pen and ink to add details, such as the numerals on the watch face, and any deep areas of shadow, including the hole in each of the keys and the points at which the solid objects are resting on the horizontal surface. Be sparing with these marks: do not be tempted to use the ink to outline every shape, or you will lose any sense of realism.

Once you are happy with the dark areas, look again at the items in front of you and try to identify the highlights. The masking fluid will have preserved small areas of white paper, but you may need to add a few extra highlights. If this is the case, you can add these using white gouache, which is an opaque paint and can be painted on top of the watercolour. Mix a small amount of white gouache with a little water to create a creamy consistency, dip the tip of the size 2 brush into the paint and test it on a scrap of paper. Apply it to the drawing where you wish to add highlights, such as the tiny reflections of the chain on the surface of the silvery key.

Use the nib, dipped in Indian ink, to enhance shapes. Do not outline every shape with ink, but just add touches to suggest small areas of shadow.

Glossary

ALLEGORICAL When the subject(s) of a work of art, or the elements that make up the composition, symbolize a deeper meaning, such as life, death, love, wealth, wisdom, and so on.

BELLY When referring to a paintbrush, the belly is the main part of the brush – the wide part of the hairs below the tip – that acts as a reservoir for liquid paint or ink. (See also Ferrule.)

BLEND(ING) To merge marks together smoothly.

BURNISH(ING) With coloured pencils, to blend marks using pressure until none of the paper surface is visible.

COLOUR WHEEL Visual device that shows the relationships between colours.

COMPLEMENTARY COLOURS Colours that are opposite each other on the colour wheel: each pair of complementaries contains all three primary colours. Complementary pairs are red and green, blue and orange, and yellow and violet.

COMPOSITION The process of arranging various elements into a design.

CONTOUR Lines drawn in a direction that follows the form or outline of an object.

CONTRAST Placing two elements next to one another – light and dark, large and small, rough and smooth – creates a focus of interest in a picture.

FERRULE This is the band – usually made of metal – that connects the bristles or hairs of a brush to the handle and holds them firmly in place.

FLAT WASH In watercolour, a smooth even layer of diluted paint.

FORM The three-dimensional nature of an object.

FORMAT The shape and orientation of a picture, most commonly landscape, portrait and square.

FROTTAGE Creating an impression of a textured surface by rubbing a pencil or other drawing material over paper placed on top of the surface.

GRAPHITE A naturally occurring form of crystalline carbon used in the manufacture of pencils.

HARMONY As opposed to contrast, harmony is the juxtaposition of similar shapes, textures, sizes and so on.

HATCHING Tonal drawing using lines.

HIGHLIGHT The lightest areas of a drawing, usually where the light is illuminating part of the subject.

HORIZON LINE A horizontal plane – not always visible in a drawing – at the viewer's eye level.

HUE Colour: red, yellow, blue, green and so on. Also, a substitute for a natural pigment in the manufacture of paints.

INCISING Creating designs by cutting into or using pressure to cause indentations in surfaces.

JUXTAPOSE To place two or more elements of a picture side-by-side.

KEY This is the tonal mood of a picture: a high-key picture includes lighter tones, while a low-key picture is darker.

LAYERING Adding colours or areas of tone on top of one another.

LINEAR PERSPECTIVE A method of depicting three-dimensionality on a flat, two-dimensional surface and an aid to drawing objects to the correct scale. Objects that are further away from the viewer appear smaller than those that are close.

MEDIUM A material used for making marks – such as pencil, charcoal or paint.

MID-TONE Variations in tone that fall between the darkest and the lightest.

MONOCHROME A single colour or a picture executed in shades of a single colour – most usually shades of black.

NARRATIVE Images that tell a story: this could be as simple as a few objects with a linked theme.

NEGATIVE SPACE The shapes of the spaces between objects.

OPACITY The opposite of transparency: the ability of a colour to obscure the colours underneath.

PERSPECTIVE A set of rules explaining that objects appear smaller the further away they are from the viewer.

PIGMENT Natural or chemical substance used in the manufacture of coloured drawing media such as paints and coloured pencils.

PLANE A level or flat surface.

PRIMARY COLOURS The only colours that cannot be made by mixing other colours: red, blue and yellow.

RULE OF THIRDS A device used to plan harmonious, balanced compositions.

SCUMBLING Shading with the tip of a pencil or coloured pencil, using a circular, scribbling motion for an even effect with no visible pencil marks; tone is built up gradually in light layers.

SECONDARY COLOURS The colours made by mixing together two primaries. Red and yellow make orange, blue and yellow make green, and blue and red make violet.

SHADING Using tone to depict shadows, light and shade, creating the illusion of three-dimensionality.

TERTIARY COLOURS Colours produced by mixing two adjacent primary and secondary colours (see colour wheels, pages 20–21).

THUMBNAIL SKETCH A small, quick drawing to assist in compositional decisions.

TOOTH The surface of a paper that is not smooth but has a certain amount of texture or roughness.

TRANSPARENCY Allowing light through. Watercolour paints, when diluted, allow light to penetrate one or more layers of washes and reflect the white of the paper back through the pigments.

VALUE This describes the degree of tone in a drawing – the lightness or darkness (see Tone, page 19).

WASH Transparent paint, such as watercolour diluted with plenty of water, laid across the surface of paper.

WET-IN-WET Adding watercolour paint to a wet surface to produce soft edges and blends.

WET-ON-DRY Adding watercolour paint to dry paper or on top of dry paint, to produce shapes with defined edges.

Suppliers

UK

Cass Art
www.cassart.co.uk

Derwent
www.derwentart.com

Jackson's Art
www.jacksonsart.com

Ken Bromley Art Supplies
www.artsupplies.co.uk

USA

Blick Art Materials
www.dickblick.com

Jerry's Artarama
www.jerrysartarama.com

Rex Art
www.rexart.com

Plaza Artist Materials
www.plazaart.com

About the Author

Susie Johns is an artist, designer and writer, and the author of dozens of instructional books on a range of different topics.

She started her art education with a Foundation course at Croydon College of Art, studied for a BA (Hons) in Fine Art at Newcastle-upon-Tyne Polytechnic and Ravensbourne College of Art and Design, then went on to do a post-graduate degree at the prestigious Slade School in London. She later gained a teaching qualification (PGCE) at University of Greenwich.

As well as teaching drawing and painting at a local community college for the last 20 years, Susie has plenty of experience running life-drawing classes and leading workshops that focus on drawing for health and well-being. She also teaches classes online on various platforms including YouTube.

To find out more about Susie and her work, you can visit www.susieatthecircus. typepad.com, follow her on Instagram: @susiejohns_artanddesign, or subscribe to her YouTube channel.

Acknowledgements

Many thanks to Jonathan Bailey for asking me to write this book, to Dominique Page for her patience, organizational skills and for editing the text so meticulously, and Ginny Zeal for designing such attractive pages.

Thanks to my father, Peter Johns, a really skilled artist, and my mother, Valerie, for teaching and encouraging me to draw from an early age and supporting me through art school, where I had the good fortune to be influenced and mentored by some incredible tutors, including Alfred Janes, George Fairley, Bruce McLean and Bruce Russell. Thanks also to my wonderful children, Josh, Lillie and Edith, for their continuing advice and input.

Index

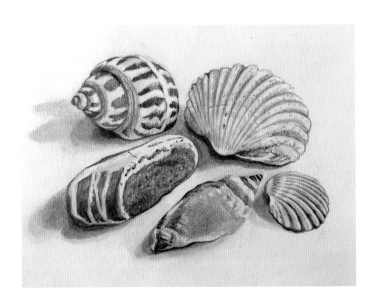

To order a book, contact:

GMC Publications Ltd

Castle Place, 166 High Street, Lewes, East Sussex, BN7 1XU
United Kingdom

Tel: +44 (0)1273 488005

www.gmcbooks.com